Jack London's

GRAND NORTH

Copyright © 2007 Editions du Garde-Temps, Paris

First published in France in 2002 by Editions du Garde-Temps, under the title *Grand Nord sur les pas de Jack London*

Designed by Michel Lelouarn
Translated by Janine Suzanne Nemerever
Consultant: Dr. Earle Labor

Library of Congress Cataloging-in-Publication Data
Lansac, Philippe.
[Grand Nord sur les pas de Jack London. English]
Jack London's grand north / Philippe Lansac.
 p. cm.
"Excerpts from the works of Jack London ; photographs by Philippe Lansac."
ISBN-13: 978-0-7627-4363-6
ISBN-10: 0-7627-4363-8
1. London, Jack, 1876–1916—Travel—Klondike River Valley (Yukon) 2. Authors, American—20th century—Biography. 3. Alaska—Description and travel. I. London, Jack, 1876–1917. Selections. II. Title.
PS3523.O46Z684 2007
818'.5209—cd22 2006027875

Manufactured in China
First Globe Pequot Edition/First Printing

Jack London's
GRAND NORTH

Philippe Lansac

Excerpts from the works of Jack London
Photographs by Philippe Lansac

The Globe Pequot Press

GUILFORD, CONNECTICUT

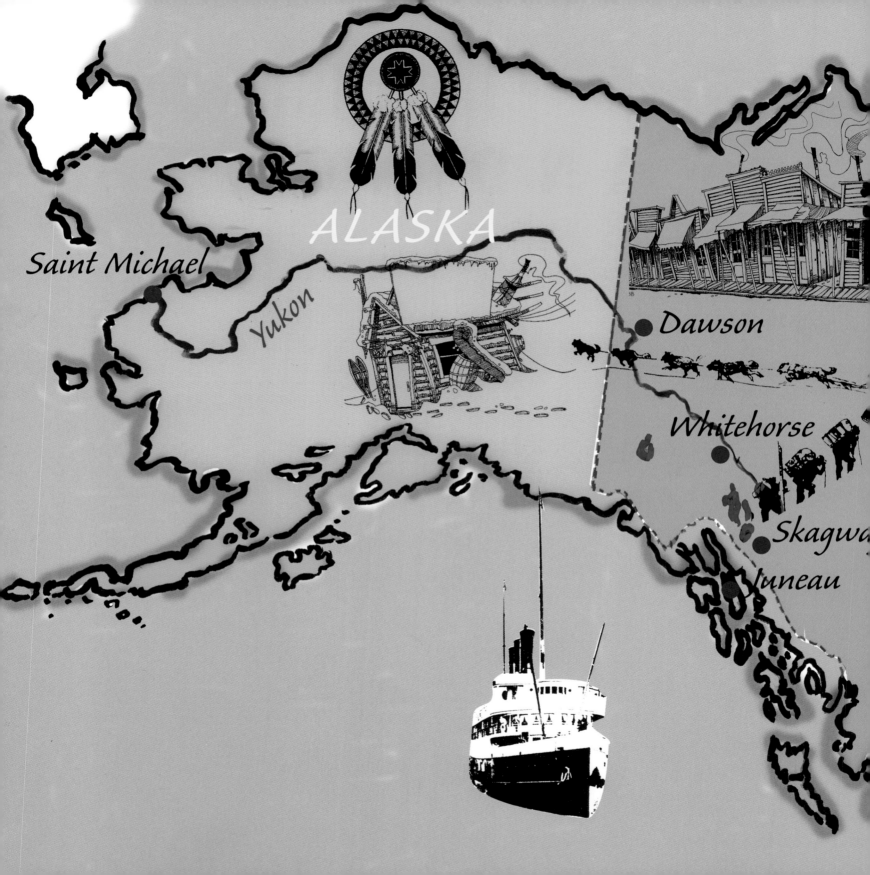

ALASKA

Saint Michael

Yukon

Dawson

Whitehorse

Skagwa

Juneau

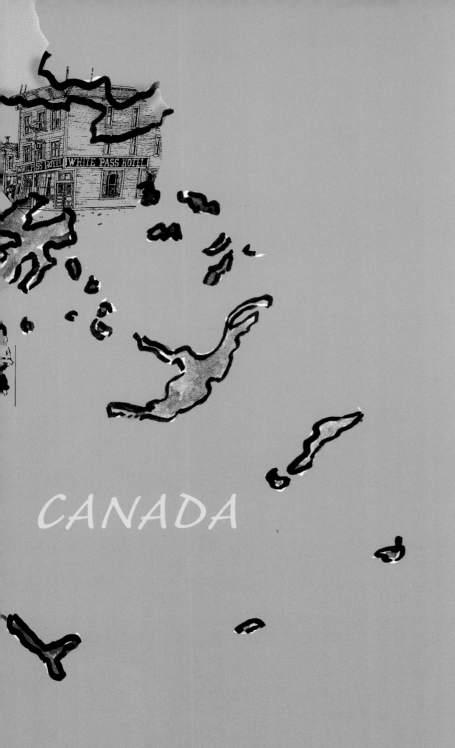

CANADA

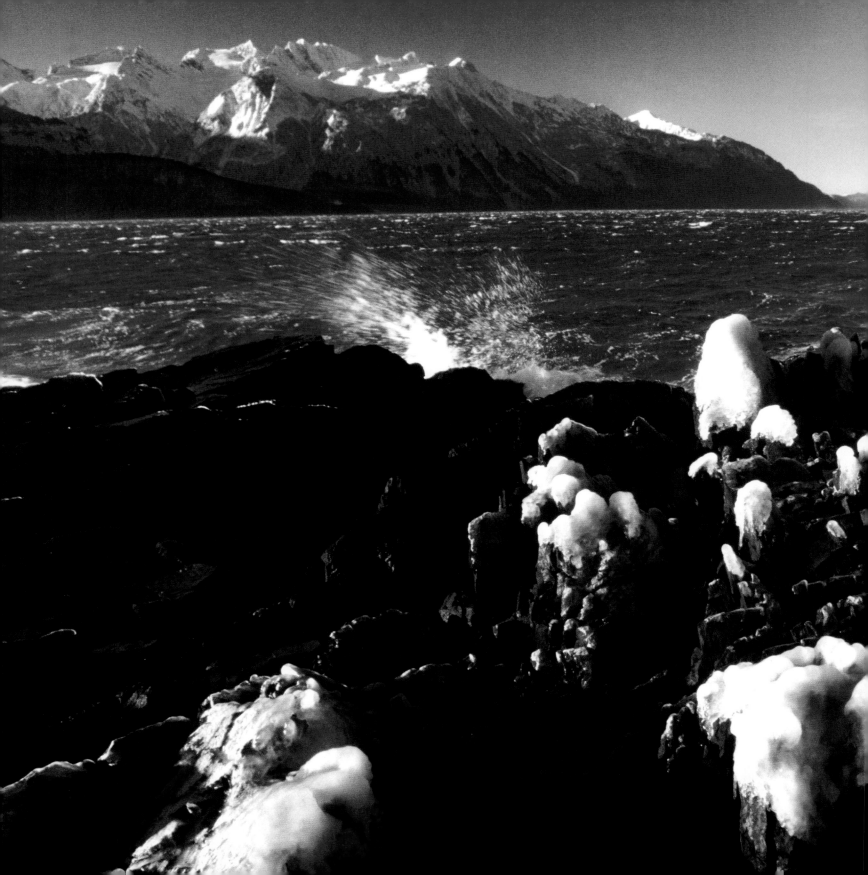

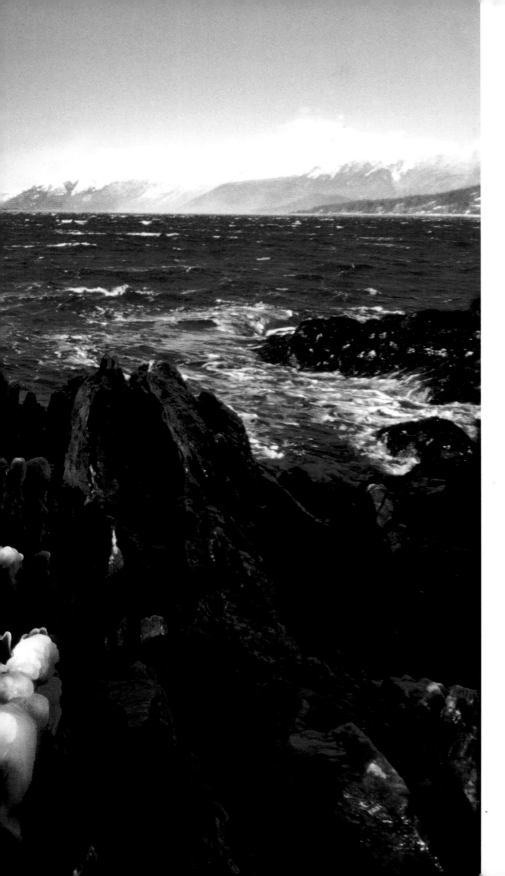

The Call of the North

Yukon Mining Journal

VOL. I DAWSON, Y. T., DECEMBER, 1900. NO. I

GOLD FIELDS OF THE YUKON.

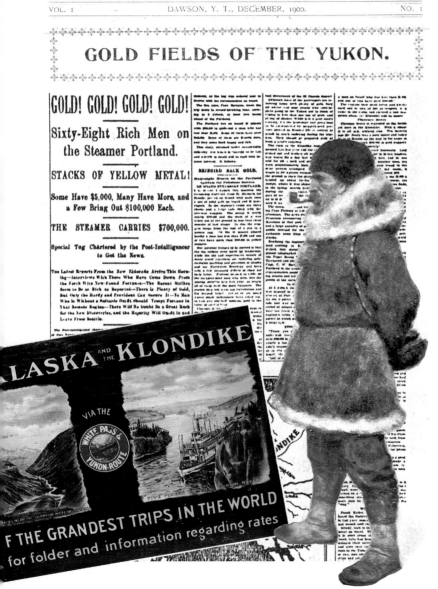

GOLD! GOLD! GOLD! GOLD!

Sixty-Eight Rich Men on the Steamer Portland.

STACKS OF YELLOW METAL!

Some Have $5,000, Many Have More, and a Few Bring Out $100,000 Each.

THE STEAMER CARRIES $700,000.

Special Tug Chartered by the Post-Intelligencer to Get the News.

"Two tickets for Juneau!" Fists clutching dollars grapple for the bars protecting the ferry company clerk. Among the crowd, a young man named Jack London fiercely defends his position in the middle of the mob with sharp jabs of his elbows. Under the hats, faces drip with sweat. It's a real fever heating the brows and blood of this crowd mad with gold lust, and with good reason. A few days before, on July 14, 1897, forty men hauling a ton of pure gold piled out of the steamship *Excelsior* onto these San Francisco docks. The equivalent of $700,000 in nuggets and gold dust was gleaned in a few weeks on the banks of the Klondike River, somewhere in northern Canada on the border of Alaska.

"Gold!" The word spreads like wildfire through this city ravaged by depression. Thanks to the telegraph, the news hits New York in a few hours, then London and the world. It's on the front page of every newspaper and resonates in the wild headlines of every newsboy's shouts. In the bars, on the docks, from the Commodity Exchange to the assembly lines, from the saloons to the church steps, everyone is talking about gold.

The stench of poverty permeating the alleyways of the San Francisco slums suddenly seems to evaporate. The gold rumor settles on empty stomachs and fills the poor with hope. In a few months, you could be a millionaire! You might get rich without doing a thing, or just about—simply grab a shovel, dig, and hit the jackpot! Just get there in time, before all the treasure is gone. The excitement is infectious. San Francisco no longer tempts pioneering souls; they will go north instead.

A Vagabond Swept Up in the Stampede

"I asked for two tickets to Juneau!" The voice is loud and commanding, the jaw square and determined, the physique that of a thug quick with his fists. At twenty-one, John Griffith London—known as Jack—is already a man, a tough one, who never knew the luxury of childhood. He shoves his way through the free-for-all, and pity the poor man who gets in his way.

Life had not been gentle on Jack. Abandoned by his father before he was born, he was raised by an unstable mother and the stepfather whose name he bore. The family had no money, and Jack soon bore the burden of bringing some home himself. He worked at odd jobs—newsboy, janitor, gardener—then at the cannery for as many as nineteen hours a day for starvation wages. But it wasn't enough. Already the family provider, Jack had to find something else to bring in money.

The "something else" turned out to be plundering oyster beds. He bought a small sloop, the *Razzle Dazzle*, and joined a gang. The nights were fruitful and the contraband lucrative. In a week he could make a year's factory wages.

At fifteen he became the "Prince of the Oyster Pirates" and an avid patron of the waterfront saloons. But one evening, while Jack was on a drinking binge, the mainsail of the *Razzle Dazzle* caught fire, and his dreams went up in smoke. So he got himself a job with the California Fish Patrol.

"Two for Juneau. Here you go. Have a safe crossing!" The departure is reminiscent of another, four years before, when Jack was an able-bodied seaman bound for the Bering Sea, Japan, and his fabulous sailing adventures aboard a sealing vessel called the *Sophia Sutherland*.

In four years, he had seemingly been and done everything—sailor, power plant worker, and socialist activist in the great march of the unemployed on Washington, D.C. Even a hobo! As a clandestine passenger on freight trains, he crisscrossed North America: Boston, New York, Ottawa, and Vancouver, with stops at the Salvation Army and even in the Erie County Penitentiary after being arrested for vagrancy. Between freight cars, to the syncopated beat of the train, the unschooled boy devoured works by Marx, Darwin, and Spencer.

In 1894 Jack celebrated his eighteenth birthday and returned to Oakland to study. He discovered he was gifted, making up for all the high school he had missed with just two years of furious study (paying tuition by sweeping the classroom floors). He was rewarded with acceptance at the University of California at Berkeley.

Six months later he abandoned his studies to devote himself exclusively to writing. Unfortunately, his literary efforts had little success with publishers, and his money problems grew.

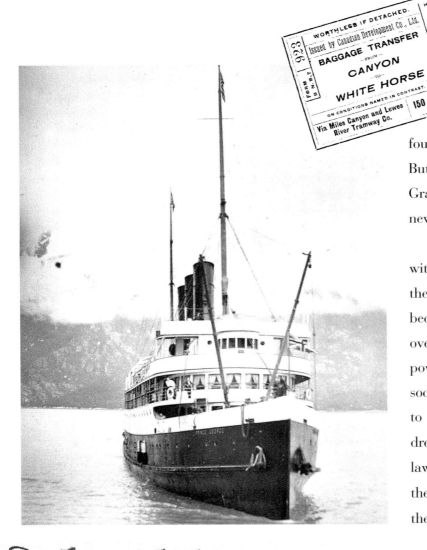

WORTHLESS IF DETACHED.
Issued by Canadian Development Co., Ltd.
BAGGAGE TRANSFER
FROM
CANYON
TO
WHITE HORSE
ON CONDITIONS NAMED IN CONTRAST.
Via Miles Canyon and Lewes
River Tramway Co.
HALF FARE
BAGGAGE CHECKED
150 Lbs.

DEPOSITED WITH
North American Transportation & Trad'g Co.
N.W.T.
May 1st 1898

Klondike gold presents itself as the obvious solution and a chance to make a fresh start.

Financing for the expedition remains to be found. First Jack seeks out the famous poet Joaquin Miller. But Miller has already left San Francisco and headed for the Grand North himself. Next Jack tries to persuade a local newspaper to send him as a reporter, but that fails.

Time is growing short. One ship after another bursting with budding prospectors leaves for the new Eldorado. Like the proverbial light at the end of the tunnel, the Klondike beckons through the gloom of the depression that has hung over the United States since the early 1890s. Say goodbye poverty, bankruptcy, and odd jobs. Whatever your station in society, you get one more chance. No one, in fact, is immune to gold fever. Small-businessmen, factory workers, hair-dressers, parish priests, prostitutes, butchers, surgeons, lawyers, and postmen: Everyone wants to go. They spend all their savings and sell their houses and businesses to finance the trip and purchase prospecting equipment.

Still, Jack has not found the means to pay his way—and he begins to panic.

Four days before the departure of the steamboat SS *Umatilla* for Alaska, Jack finally flushes out a grubstaker in the person of James Shepard, his sister's husband. Shepard agrees to mortgage his house, but only if he is allowed to go, too! Jack tries to dissuade his brother-in-law, who is over sixty, explaining the dangers of such an expedition, but in a hurry to leave, Jack finally agrees.

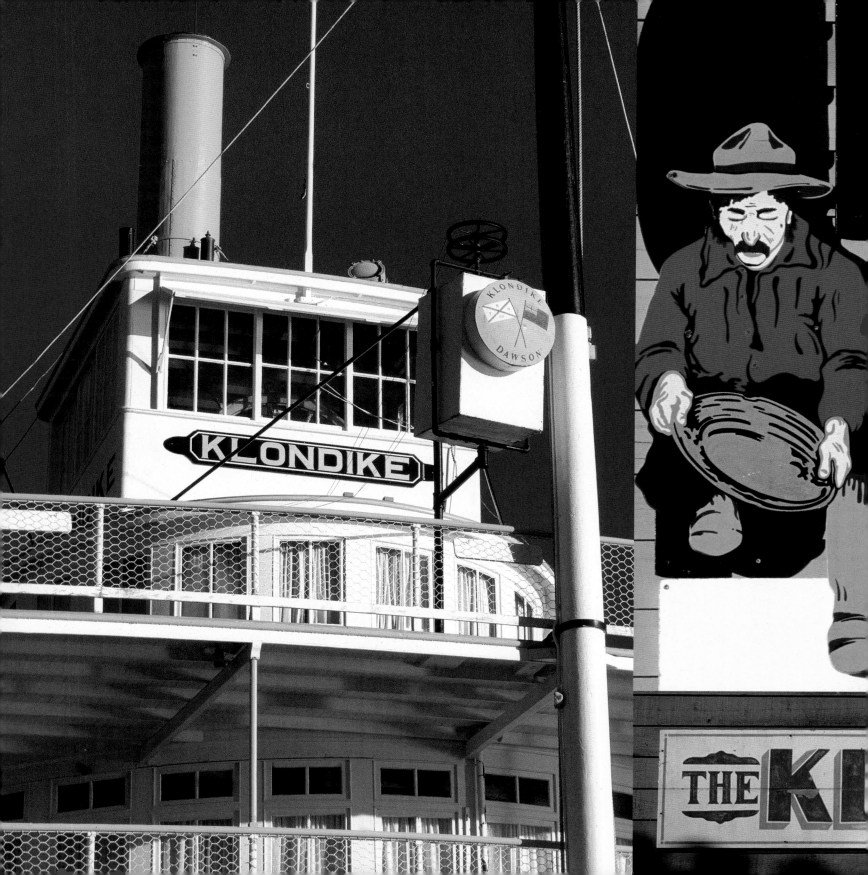

July 25, 1897. The first ship is leaving for the Klondike since the great news broke. A tide of hysterical humanity fills the San Francisco dock. "Out of my way!" yells Jack, ploughing through the crowd.

Since 5:00 in the morning, in a terrifying state of chaos, he has been packing his prospecting equipment and provisions. Now, at all costs, he must get himself a place on that teeming deck. Barely a square inch of space remains amid the mountains of trunks, cases crammed with tools, bags of dried beans, and tins of food—not to mention the chickens, dogs, and even horses. There is a veritable menagerie amid the human passengers seated shoulder-to-shoulder on the top deck, their legs dangling over the guardrails. The demand was so overwhelming that the company sold tickets to twice as many people as the steamer was licensed to carry. Two hours behind schedule, the siren suddenly blasts. At last, in a cloud of black smoke, the signal for departure is given. Caps are hurled in the air with shouts, whistles, and howls of joy. Eyes gleaming with visions of nuggets and ingots, the spur-of-the-moment adventurers bid their last goodbyes.

Once the news broke of the discovery of gold, a myriad of newspaper ads appeared, urging smaller shareholders to invest in the new mining companies. *Buy stocks and earn millions!* Photos of gold nuggets "direct from the Klondike" provided proof for the hesitant.

GOLD NUGGETS
Direct from the Klondike.

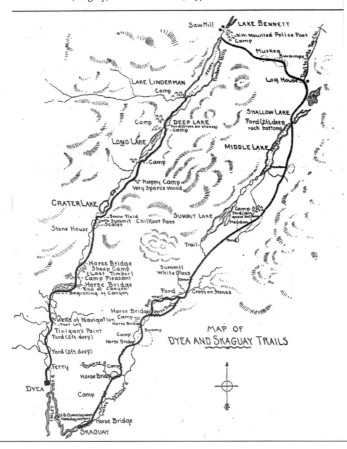

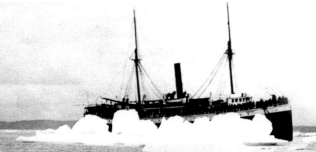

On the overcrowded ships, passengers exchange the few available maps to the paradise of gold. There are two ways to travel inland from the Pacific coast: Chilkoot Pass or White Pass. This map, however, comes with a warning: "Whichever way you go, you will wish you had gone the other."

It's an eight-day voyage from San Francisco to Seattle, past Vancouver Island, and through the famous Inside Passage, an immense natural channel sheltered from the north Pacific storms by a labyrinth of rocks and islands. During those days at sea, the discussions are endless and intense. Partnerships are formed and pacts are made in the smoke-filled cabins. Maps of the Klondike are passed through so many hands that the bona fide documents are barely visible under all the pencil marks.

Jack and his brother-in-law find three partners to share their adventure: Merritt Sloper, Jim Goodman, and Fred Thompson. Merritt, a man in his forties, has just returned from a long voyage to South America. Carpentry is his specialty, a skill that will be put to good use when they build their small boat. Jim, a regular mountain of muscle, is already an experienced placer miner. As for Fred, he offers the sound physical condition of youth in addition to business sense and a talent for organizing. It will be Fred who records their exploits in the logbook.

A Wave of Humanity Breaks on Dyea's Shores

On the second of August, Jack and his companions land in Juneau and head for Dyea with five tons of equipment in 70-foot Indian canoes. Four days of paddling get them to Dyea Beach, which is already swarming with gold seekers and strewn with gear. From here the army of prospectors set out for the Klondike River near Dawson City, 560 miles north of the Pacific coast.

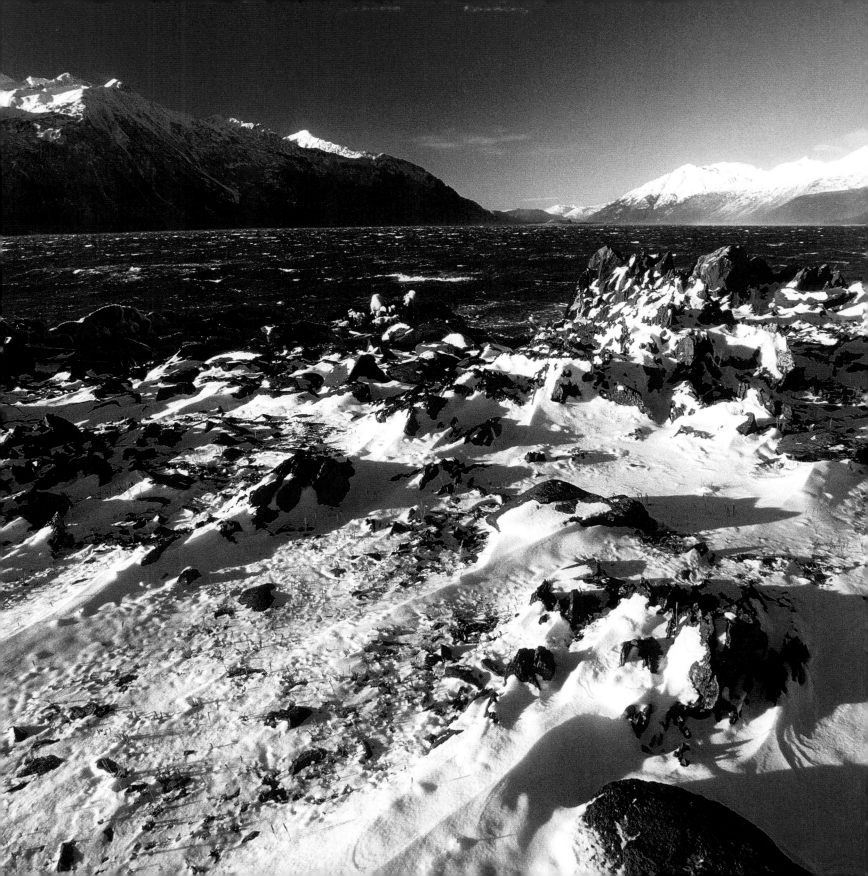

Kit Bellew landed through the madness of the Dyea beach congested with the thousand-pound outfits of thousands of men. This immense mass of luggage and food, flung ashore in mountains by the steamers, was beginning slowly to dribble up the Dyea Valley and across Chilkoot. It was a portage of twenty-eight miles, and could be accomplished only on the backs of men. Despite the fact that the Indian packers had jumped the freight from eight cents a pound to forty, they were swamped with the work, and it was plain that winter would catch the major portion of the outfits on the wrong side of the divide.

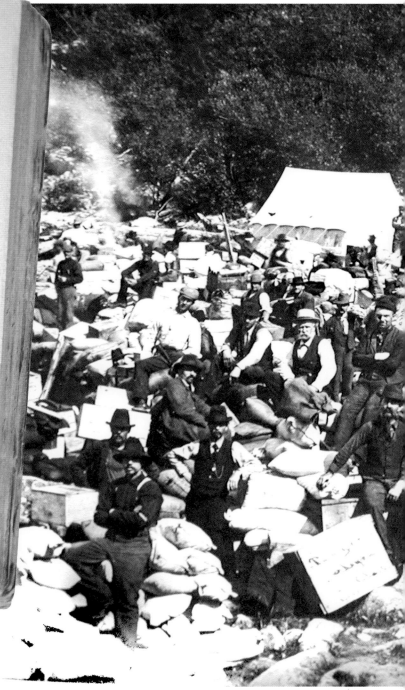

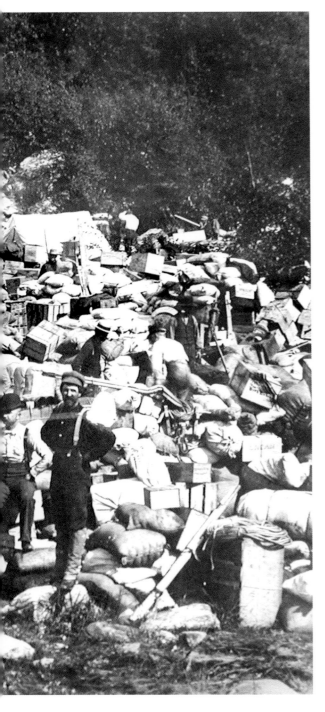

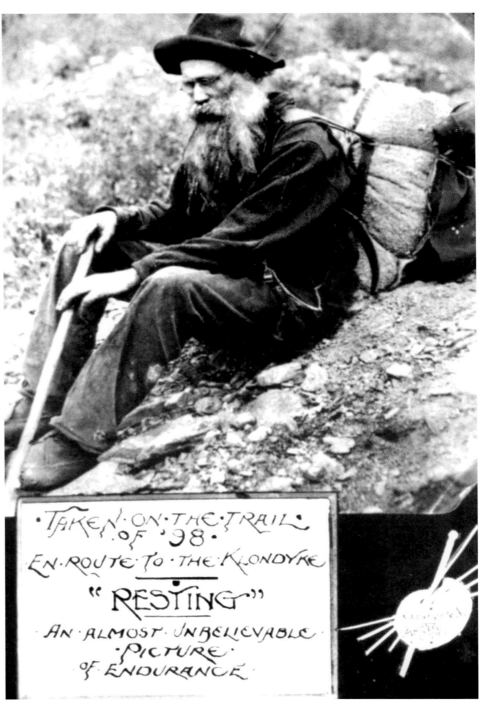

TAKEN·ON·THE·TRAIL
·OF·'98·
EN·ROUTE·TO·THE·KLONDYKE

"RESTING"

AN·ALMOST·UNBELIEVABLE
·PICTURE·
OF·ENDURANCE

Forced March over Chilkoot

Sitting in the mud surrounded by huge wooden boxes stacked on the beach, Jack takes stock of the damage. They've barely arrived and he's already worn out. Because his brother-in-law is in poor health and too old to carry much cargo, Jack has had to unload all their possessions from the canoe by himself. Just to reach the Klondike, they must first climb the terrible Chilkoot Pass: a brutal 280-foot ascent in just 19 miles of trail. At the summit are the Canadian border and a post of the Canadian Mounted Police. No traveler will be allowed to enter Canada without a minimum of one year's provisions to get through the winter—in other words, a load weighing more than one ton!

The next day the nightmare begins. Carrying from seventy-five to one hundred pounds on his back, Jack tackles a trail reduced to a river of mud by the torrential rains. He and his new friends must make between ten and twenty round trips each to haul their required 1,000 pounds of supplies to the summit. James Shepard, Jack's brother-in-law, finally faces facts: "I give up. Go on without me. I'm catching the first steamer back to San Francisco."

The rest of them face three weeks of torture, a twenty-day forced march in an endless line of porters to reach the top of the pass.

Bad as it is, Jack is spared the worst—winter. Even snowstorms and avalanches can't stop the influx of men. But they do transform the Chilkoot into a symbol of a mad stampede, which has since been immortalized in photographs.

"A whole bunch of stories about the Klondike in all the newspapers of the world created this fever and this rush to the Klondike. And then, in addition to the stampeders who came up here, the reporters came up, and also the photographers to tell the story and report to the readers back home. You had a number of professional photographers, but you had also the amateurs, because by that time Kodak and the other companies were developing amateur films and amateur cameras. The film speeds were getting faster, enough that people could literally take snapshots without having to stand there for a couple of minutes, really stiff and all that, to pause for the picture. So you had the professionals with their big glass-plate negatives coming up and then you had the amateurs with the little small cameras taking pictures as well. It was pretty chaotic. There were thousands of people in town, more people coming off the boats; nobody really knew what they were going to do, how to get over, what the conditions of the trail were. And they did not quite understand the distances involved. They were not quite sure if they had enough food, enough supplies. There were people setting up shops here and there to help supply them with food and their outfits, but there were also saloons coming up, and gambling houses spreading, and prostitution. It was just a chaotic scene. In Skagway and also in Dyea there was not really any law and order."

—Karl Gurke, historian at Klondike Gold Rush National Historical Park, Skagway, Alaska

Outfit Kit for One Prospector

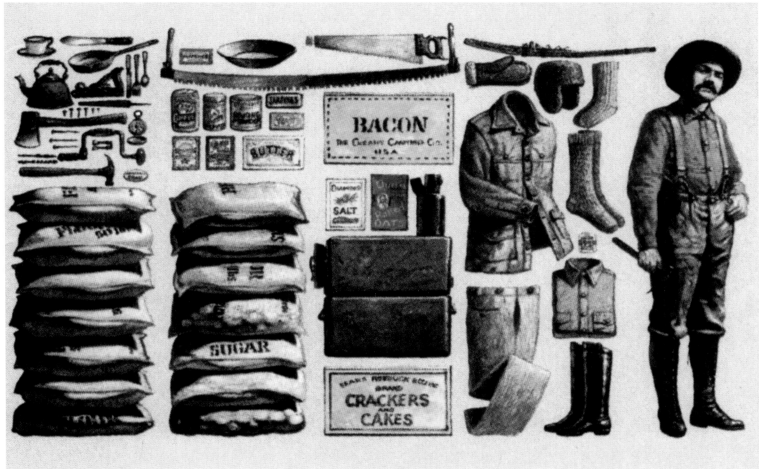

Provisions

Bacon—200 lbs.

Flour—400 lbs.

Rolled Oats—50 lbs.

Cornmeal—50 lbs.

Rice—40 lbs.

Coffee—25 lbs.

Tea—10 lbs.

Sugar—100 lbs.

Salt—15 lbs.

Pepper—1 lb.

Butter—25 Boxes

Dried Fruit—100 lbs.

Clothing

1 Winter Coat

3 Long Johns

12 Pairs Wool Socks

2 Pairs Mackinaw
Pants

6 Pairs Fingerless
Mitts

3 Pairs Mittens

1 Fur Cap

2 Heavy Wool Shirts

2 Pairs Rubber Boots

2 Pairs Miner's Shoes

Equipment

1 Yukon Stove

1 Gold Pan

2 Buckets

2 Sets of Billycans

Knives, Forks, Spoons

Coffeepot, Teapot

Pot Handles

Sewing Needles

Mosquito Netting

Hammer and Nails

1 Hatchet

1 Jack Plane

2 Whip Saws

1 Drill

1 Compass

60 Boxes of Matches

50 lbs. of Candles

1 Medicine Kit

1 Tent

3 Ropes

5 Cakes of Soap

3 Heavy Blankets

1 Tarpaulin

2 Sheets

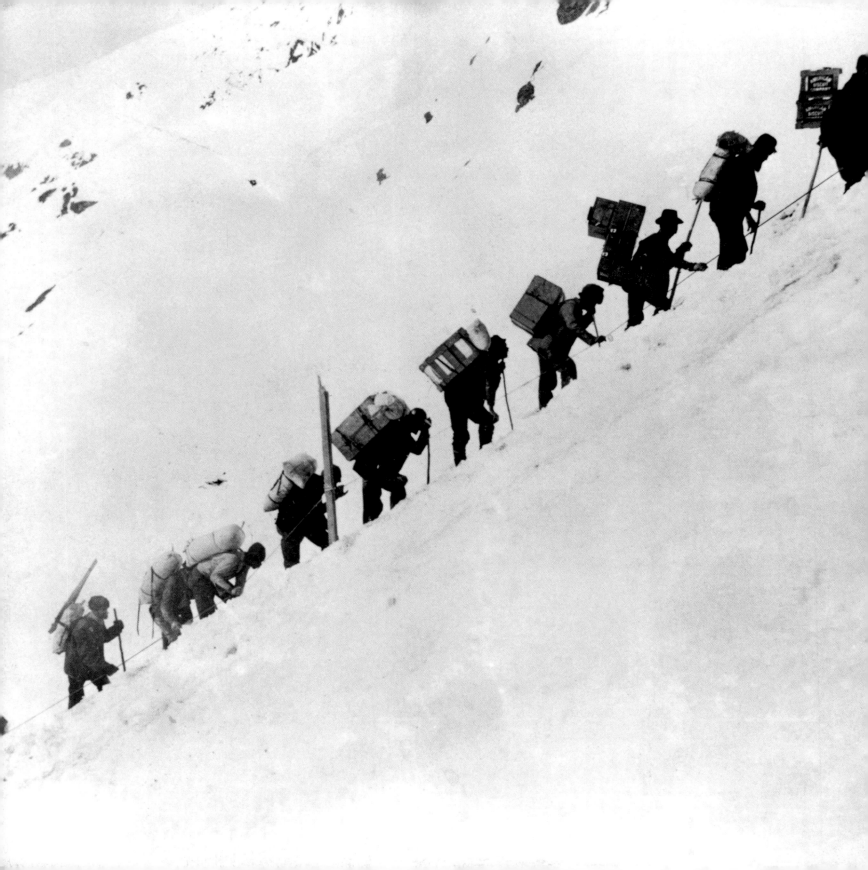

On either hand rose the ice-marred ribs of earth, naked and strenuous in their nakedness. Above towered storm-beaten Chilcoot. Up its gaunt and ragged front crawled a slender string of men. But it was an endless string. It came out of the last fringe of dwarfed shrub below, drew a black line across a dazzling stretch of ice, and filed past Frona where she ate her lunch by the way. And it went on, up the pitch of the steep, growing fainter and smaller, till it squirmed and twisted like a column of ants and vanished over the crest of the pass.

Even as she looked, Chilcoot was wrapped in rolling mist and whirling cloud, and a storm of sleet and wind roared down upon the toiling pigmies. The light was swept out of the day, and a deep gloom prevailed; but Frona knew that somewhere up there, clinging and climbing and immortally striving, the long line of ants still twisted towards the sky.

Packing Up Chilcoot Pass

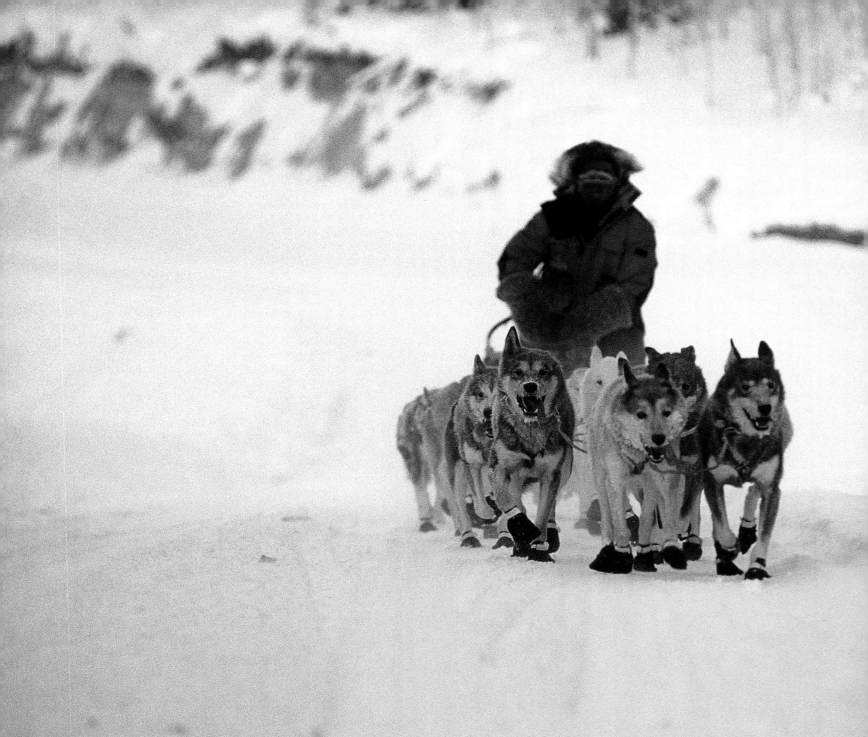

Hell on the Trail

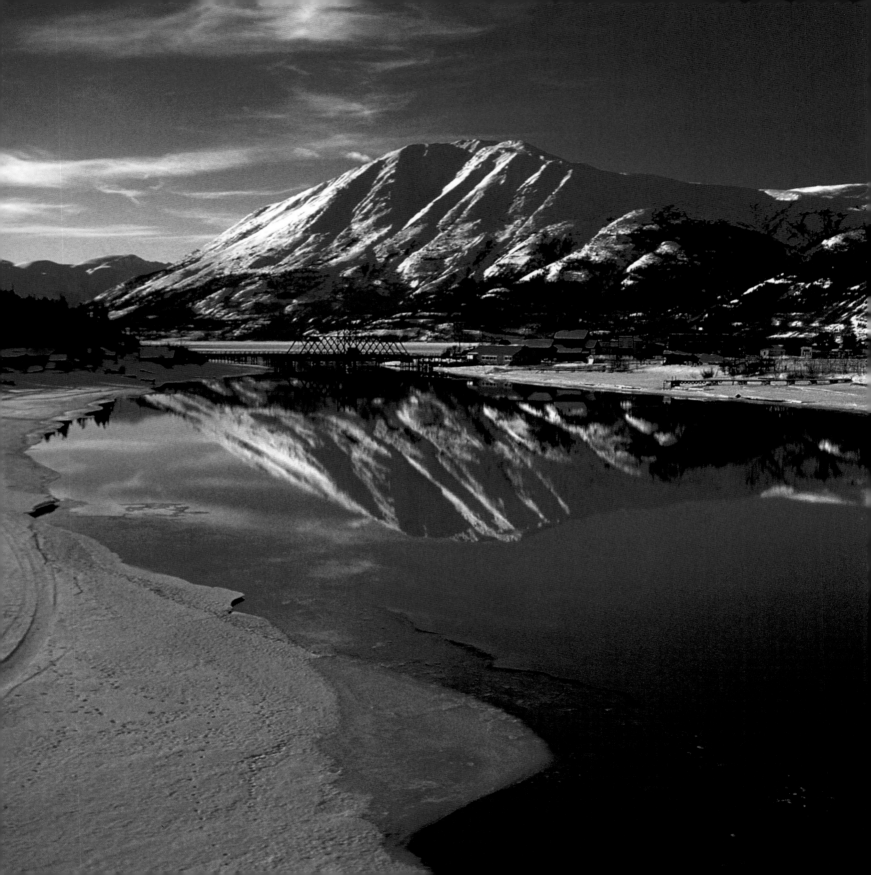

The final destination of Jack London and his fellow victims of gold fever was the Klondike River, 600 miles north of Dyea Beach and Skagway. Before they could even begin their search, they needed to conquer the trail—600 miles of what appeared to be an obstacle course.

Shooting the Rapids

The rain finally seems to be slowing down on the other side of Chilkoot Pass. As he pounds down the path leading to Lake Linderman, Jack wonders if the Coastal Mountains are actually blocking the bad weather from the Pacific or if it's just an illusion brought on by relief at having survived such an ordeal.

The banks of the great expanse of water filling the valley are always crowded with men. In a few weeks this village of some hundred tents that sprang out of nowhere has been surrounded by a real shipyard. Everywhere men are sawing, using planes, and hammering. The forest nearby has already been so heavily logged that they must go farther and farther to find wood. Rapidly the hulls take shape. Rowboats, sailboats, canoes—anything at all that will get the men going again as fast as possible. Now they race the winter, which will turn their route to ice.

"Now all we have to do is step the mast and hoist the sail!" shouts Jack to his companions. Although the youngest of the team, he will oversee the work. Sloper and London are the only ones with any real sailing experience.

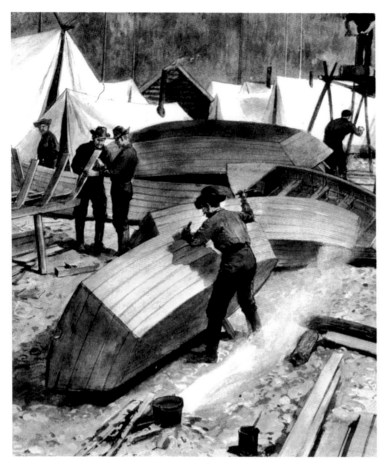

"It was in the Klondike I found myself. There nobody talks. Everybody thinks. You get your true perspective. I got mine."

—Jack London

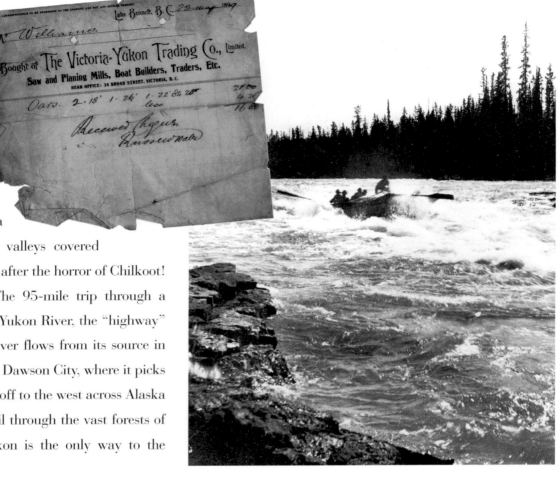

After ten days of frantic work, the *Yukon Belle* is launched. Thanks to Jack's fine homemade sail, she whips across Lake Bennett, leaving the other boats in her wake. Tiller in one hand, sheet in the other, Jack joyfully sails his boat. Around him unfolds a magnificent landscape of broad valleys covered with gigantic forests. Peace at last after the horror of Chilkoot!

They make good progress. The 95-mile trip through a chain of lakes brings them to the Yukon River, the "highway" to the Klondike. This immense river flows from its source in British Columbia straight north to Dawson City, where it picks up the Klondike River, then splits off to the west across Alaska to the Bering Sea. There is no trail through the vast forests of the Grand North. The wide Yukon is the only way to the Promised Land.

"Hang on!" Jack yells, feeling the *Yukon Belle* gathering speed in the suddenly more powerful current.

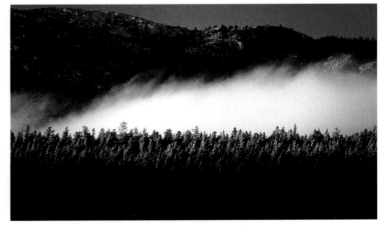

Many Klondikers saw their dreams of fortune literally swept away in the rapids of Box Canyon.

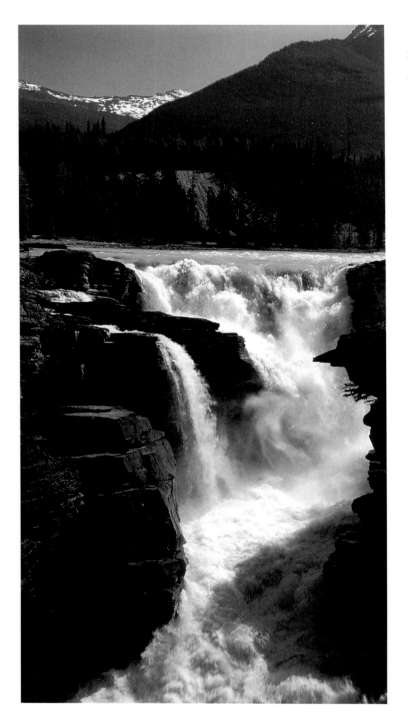

Several hundred yards ahead, the Yukon narrows dramatically. This must be the infamous Box Canyon. For several weeks now, a disquieting rumor has been circulating of dozens of gold seekers who have capsized in these terrible rapids and watched their dreams vanish in the churning water.

Before entering, Jack ties up on the bank to take stock of the situation. The canyon is aptly named. Here the entire volume of this mighty river roars through a narrow stone corridor in a maelstrom of whirlpools and raging waves. Many prospectors have prudently unloaded their equipment and skirted the terrifying passage on terra firma.

Jack hesitates, but not for long. Confident in his ability as a captain, he positions his crew. Jack puts Sloper, who has some experience, in the bow with a paddle to steer clear of the rocks. Thompson and Goodman, who have never sailed, take the oars in the middle. Jack mans the steering oar from the stern.

As soon as they cast off, a powerful current sucks the *Yukon Belle* toward the narrow canyon. The boat hurtles down the rapids at top speed, tossed in every direction. Drenched to the skin, Jack bellows orders to his comrades. Above all they are to hold their course down the center of the canyon, or they are sure to be smashed against the cliffs! Buckets of icy water rain down on the struggling crew.

All at once a great cracking noise shakes the hull, caught in a deeper trough. But the *Yukon Belle* holds fast. The road to gold opens before the crew once more. Just 435 miles to go . . .

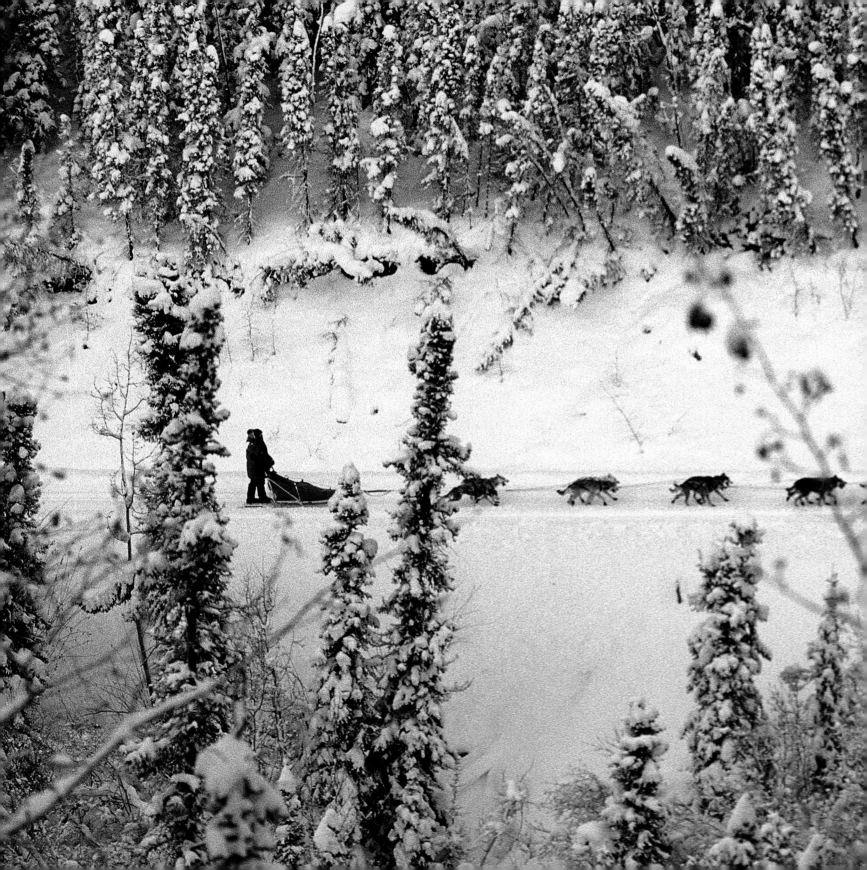

The White Silence

In the Grand North, the trail is Hell. It is muddy paths in glacial rain, steep passes, and, above all, the terrible Yukon, that river of eddies and, rapids that freezes over for the eight months of winter.

While Jack makes his trek to Dawson in the autumn, many prospectors follow by dogsled on the frozen surface of the river, with all the dangers that entailed. In a blizzard at forty below, the slightest incident can prove fatal. Death keeps a hungry eye on the careless and unprepared.

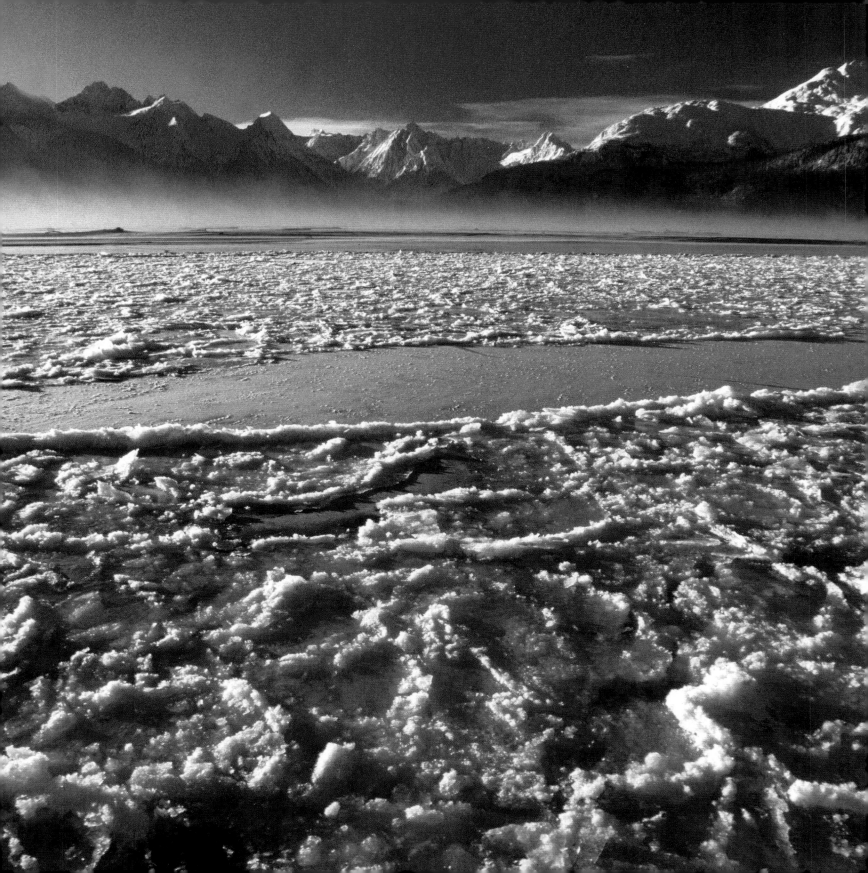

The afternoon wore on, and with the awe born of the White Silence, the voiceless travelers bent to their work. Nature has many tricks wherewith she convinces man of his finity—the ceaseless flow of the tides, the fury of the storm, the shock of the earthquake, the long roll of heaven's artillery—but the most tremendous, the most stupefying of all, is the passive phase of the White Silence. All movement ceases, the sky clears, the heavens are as brass; the slightest whisper seems sacrilege, and man becomes timid, affrighted at the sound of his own voice. Sole speck of life journeying across the ghostly wastes of a dead world, he trembles at his audacity, realizes that his is a maggot's life, nothing more.

Strange thoughts arise unsummoned, and the mystery of all things strives for utterance.

And the fear of death, of God, of the universe, comes over him—the hope of the Resurrection and the Life, the yearning for immortality, the vain striving of the imprisoned essence—it is then, if ever, man walks alone with God.

Winter has descended on the Yukon. The temperature drops day by day. The lakes freeze first and almost instantly. Already you can walk on translucent stretches so smooth that they seem unreal. One night it hits thirty-one below, and the Yukon itself freezes over. A crust of ice has covered its surface, but here and there the steaming water manages to break through and pursue its course a little while longer.

There arrives a patch of milder weather; a moist wind blows in from the Pacific, and all the trails disappear under a blanket of snow. The flakes are as light as flour. Here in the interior, where the climate is considered to be half-desert, there is little precipitation and far less snow than in Quebec or around Hudson Bay. But once the snow falls, it's there for the rest of the winter.

For Jack and his crew, the snow squeaks like fine sand under their moccasins. Beaver caps and mittens are hauled out, and a dogsled glides across the frozen surface of Fish Lake. The motionless air seems suspended above the earth and mustaches are coated with ice. The temperature hasn't risen above minus forty in five days. The "White Silence" now reigns in the Yukon.

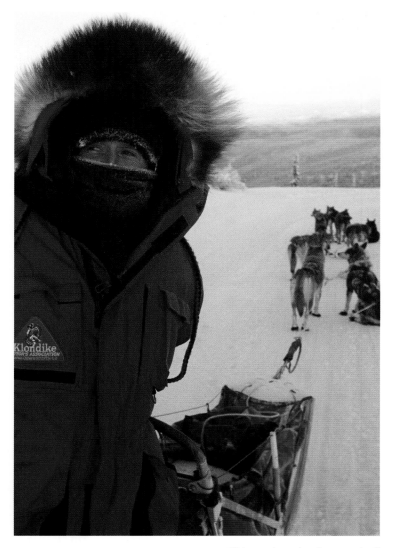

This modern-day "prospector" tent being hauled north of Dawson by two trappers is equipped with a woodstove.

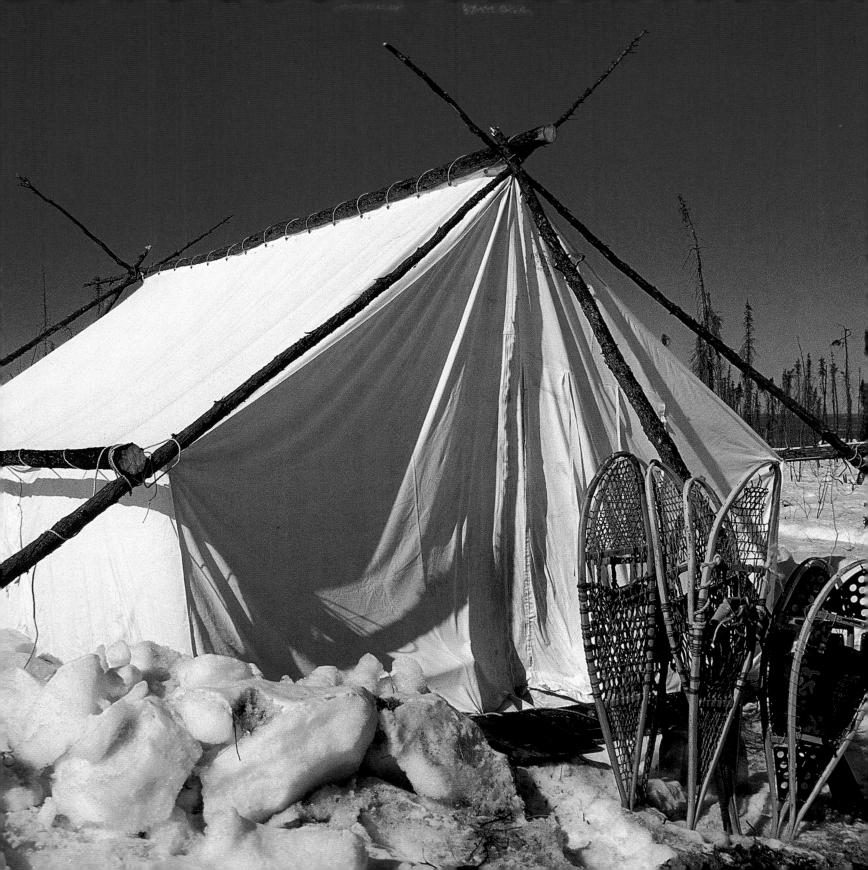

"Once, it was minus seventy degrees Celsius all through January. The whole month.... I was at the mission and I couldn't travel. At temperatures like that, you're afraid that the dogs' lungs will freeze. An Indian came on a sled. He said, 'John and his family have lost all their dogs and they don't have anything left to eat.' I went to see the boy at the post office and said someone has to go save that family, and he replied, 'I'm coming with you.' We took some provisions and left. That family was 25 or 30 miles away from the mission. We started out, but the boy had never walked in moccasins before. He had big boots with snowshoes. It was around 10:00 or 11:00. So I said, 'It's 30 miles away. We can do that by late this evening.' But he couldn't walk anymore. He kept falling, the poor guy. First one way, then the other. He was completely worn out. So I told him, 'Maurice, I know a spot where there's lots of wood. That's where we're going to camp.' We didn't have a blanket or anything because I was thinking we'd reach the Indians' tent and we'd be warm inside. But we weren't there yet.... It was seventy-three below zero in Ross River that day. We set up camp and built a fire. We were burning on one side and freezing on the other and tossing and turning all night long! And then in the morning... around 7:00 we could make out the path. After a mile or two, my pal said to me, 'Pierre, I think I've frozen my feet.' 'Then we'll stop and light a fire. Get your boots off, and we'll take a look!' His feet weren't frozen but they were all white. I waited for him to warm up and then we took off again. We weren't far from the tent, about 3 or 4 miles. We got there, and we sure were happy. We gave some food to the Indian and his wife and their three little girls. One was four years old, one was two, and one was four months. So they ate. On the way back, we saw clouds on the mountain tops. I said, 'Well, it's warming up!' When we got to Ross River it was only fifty below zero.... We were pretty tired so I called an Indian who knew my dogs. I told him, 'Harness up the dogs. You go and you bring back that family. No stopping. Just go up there and come back.' He did those 30 miles in the dark. He got there, and we saved that family. Otherwise they would have died."

—Jean-Pierre Rigault, eighty-eight, missionary in Ross River in the Yukon since 1947 (November 2003)

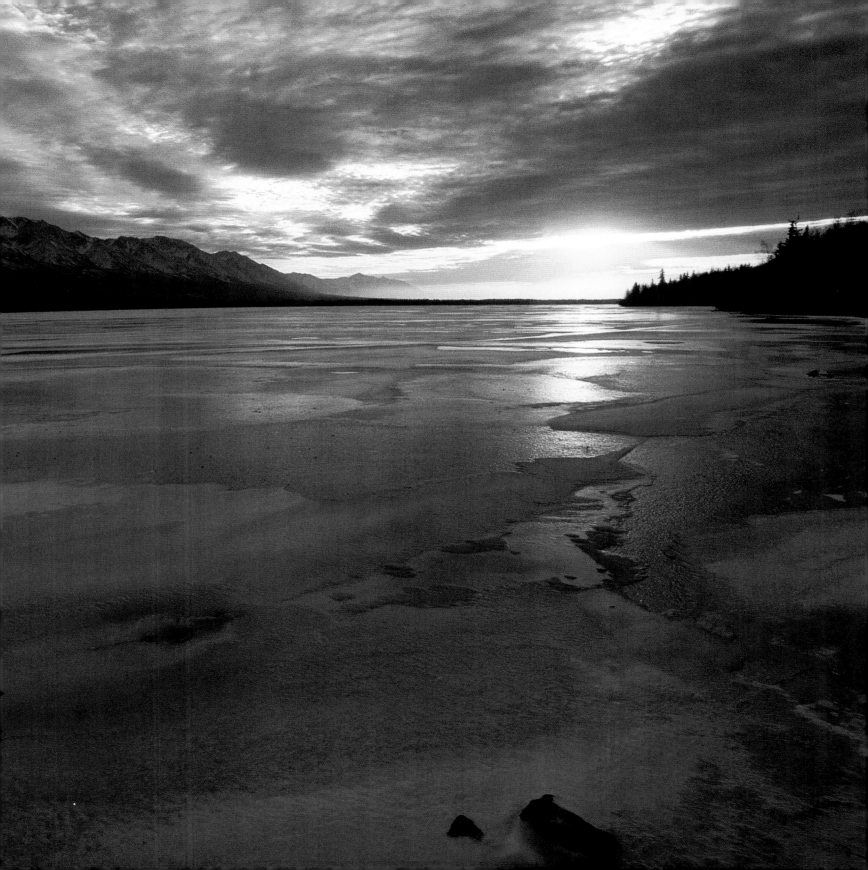

The Call of the Forest

In the Grand North, it's winter that lays down the law, and it must obeyed. When the mercury plunges to forty below, you can no longer count on many everyday certainties, physical as well as psychological. Iron shatters like glass. Skin sticks to metal. Even your lungs can freeze.

In this virgin wilderness, man rediscovers a primitive freedom. Here only those who adapt survive—those who can endure the intense cold, hunt down animals for food, "listen" to the forest. To claim your place in nature, you must reawaken all your senses. Life is teeming all around you in the Arctic desert, and it will catch you unawares. It demands a true return to the savage state. You must know how to accept that. To hear "the call of the wild."

The Grand North. Its story is one of passion—of beauty and danger, fascination and suffering, life and death. Its call can be hard to resist.

1984-1993

YUKON QUEST
WHITEHORSE • 1000 Miles • FAIRBANKS

10 Years On The Trail

The Yukon Quest, the "Toughest Sled Dog Race in the World," takes place every year in mid-February. The starting line of the 1,000-mile competition is in Whitehorse; the halfway mark is in Dawson City; and the finish line is in Fairbanks, Alaska.

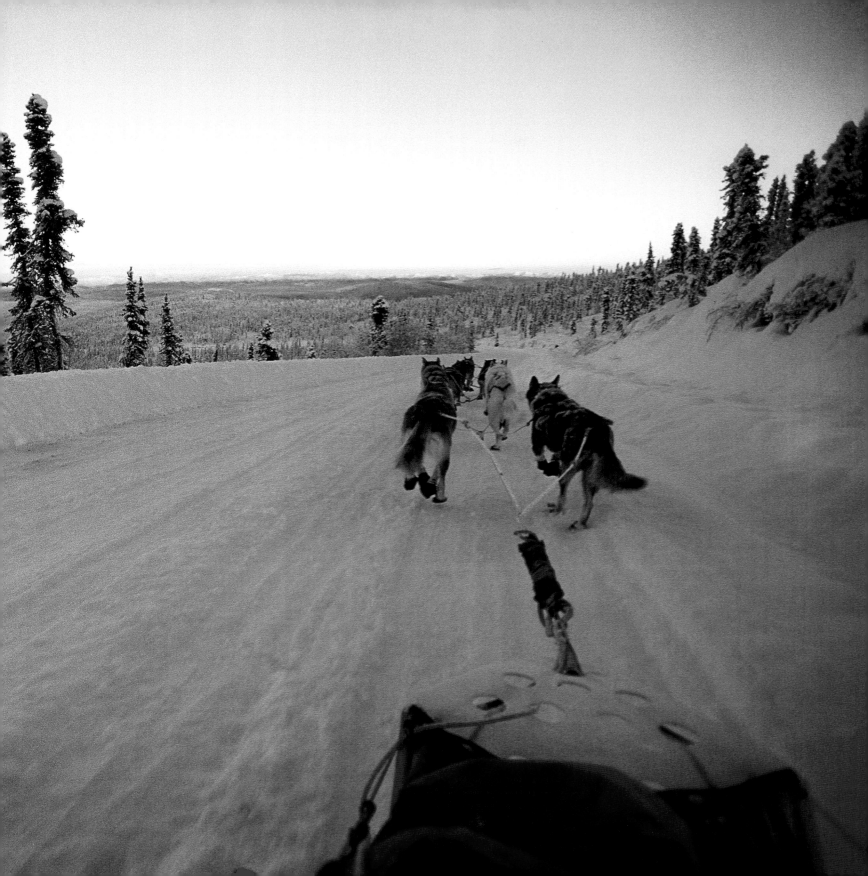

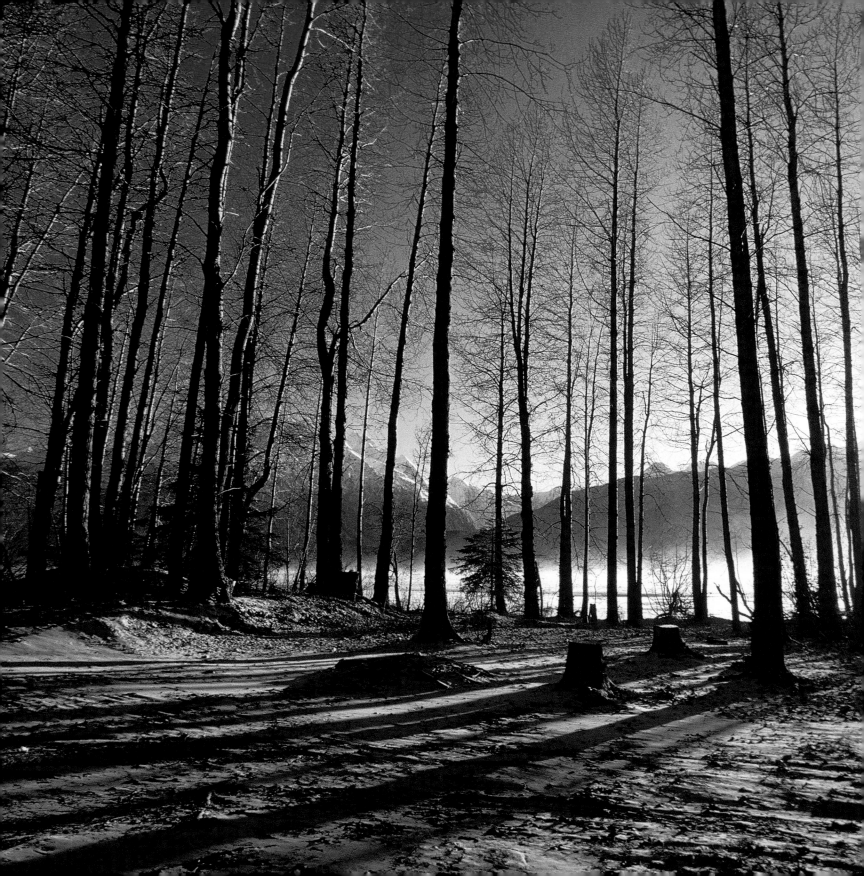

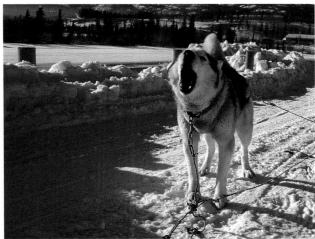

So peremptorily did these shades beckon him, that each day mankind and the claims of mankind slipped farther from him. Deep in the forest a call was sounding, and as often as he heard this call, mysteriously thrilling and luring, he felt compelled to turn his back upon the fire and the beaten earth around it, and to plunge into the forest, and on and on, he knew not where or why; nor did he wonder where or why, the call sounding imperiously, deep in the forest.

Brown Bear

Polar Bear

It was a clear, cold night, not over-cold,—not more than forty below,—and the land was bathed in a soft, diffused flood of light which found its source not in the stars, nor yet in the moon, which was somewhere over on the other side of the world. From the southeast to the northwest a pale-greenish glow fringed the rim of the heavens, and it was from this the dim radiance was exhaled. Suddenly, like the ray of a search-light, a band of white light ploughed overhead. Night turned to ghostly day on the instant, then blacker night descended. But to the southeast a noiseless commotion was apparent. The glowing greenish gauze was in a ferment, bubbling, uprearing, downfalling, and tentatively thrusting huge bodiless hands into the upper ether.

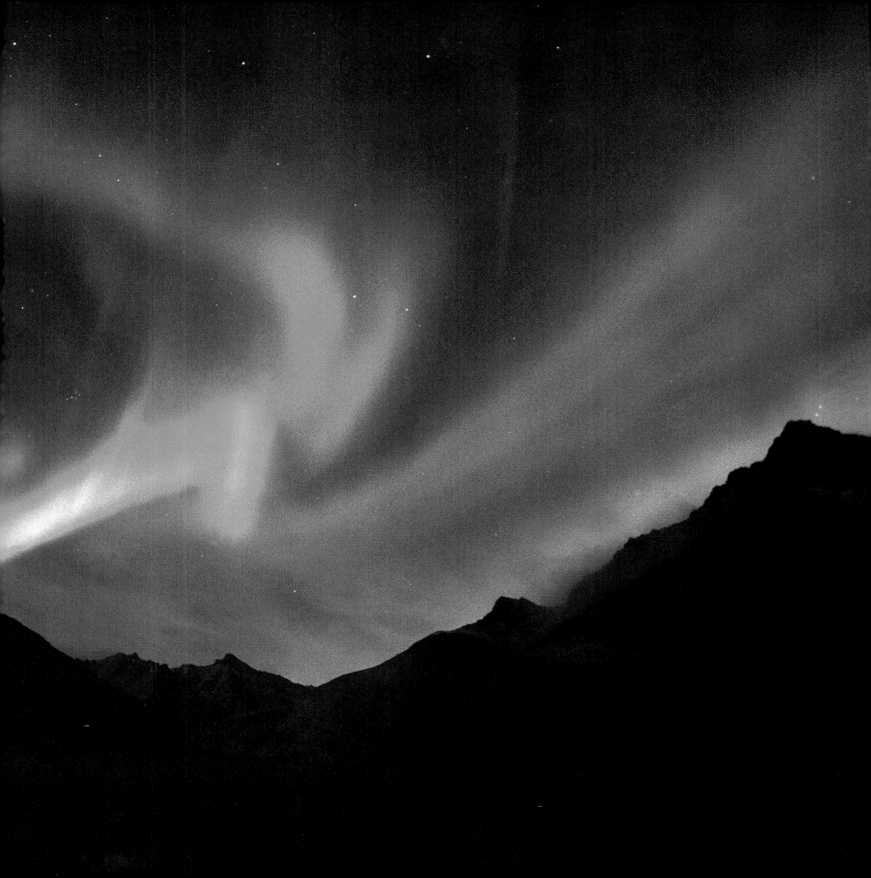

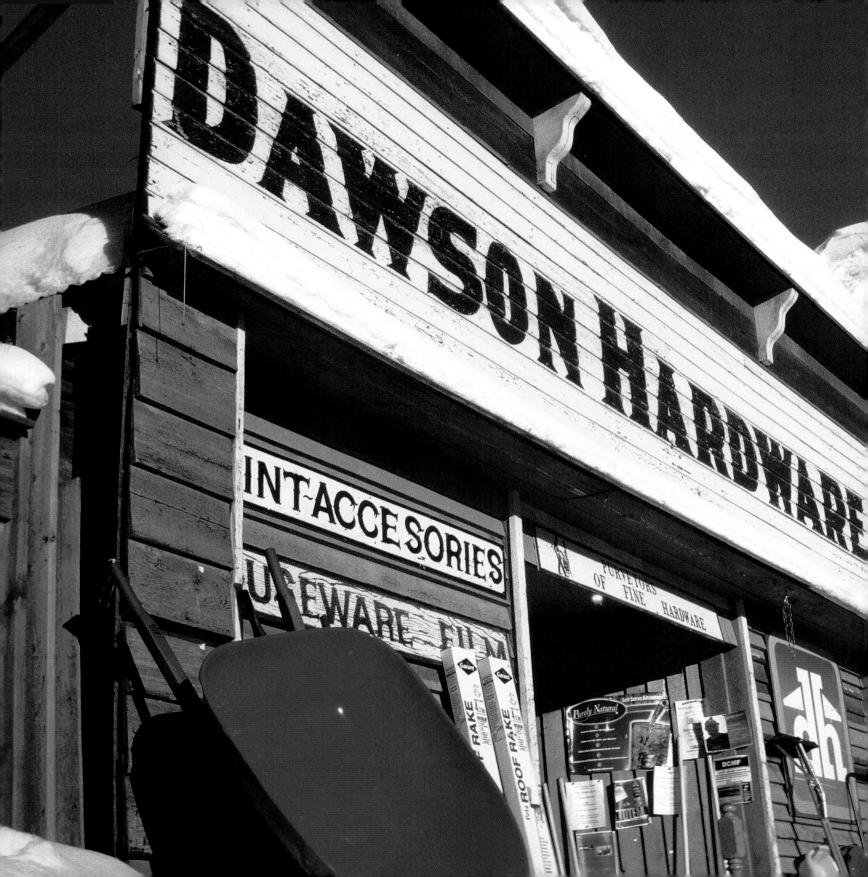

A New Eldorado

YUKON
BREWING COMPANY
WWW.YUKONBEER.COM

YUKON
GOLD

Top Rated Canadian
Golden Ale

BEER WORTH FREEZIN' FOR

DAWSON

OFFICE

DORADO

ILY NEWS

One day, the Upper Country, which lies far above Circle City, was pronounced rich. Dog-teams carried the news to Salt Water; golden argosies freighted the lure across the North Pacific; wires and cables sang with the tidings; and the world heard for the first time of the Klondike River and the Yukon Country.

[. . .] Besides, there drifted down the river wild rumors of the wonderful Eldorado, glowing descriptions of the city of logs and tents, and ludicrous accounts of the che-cha-quas who had rushed in and were stampeding the whole country.

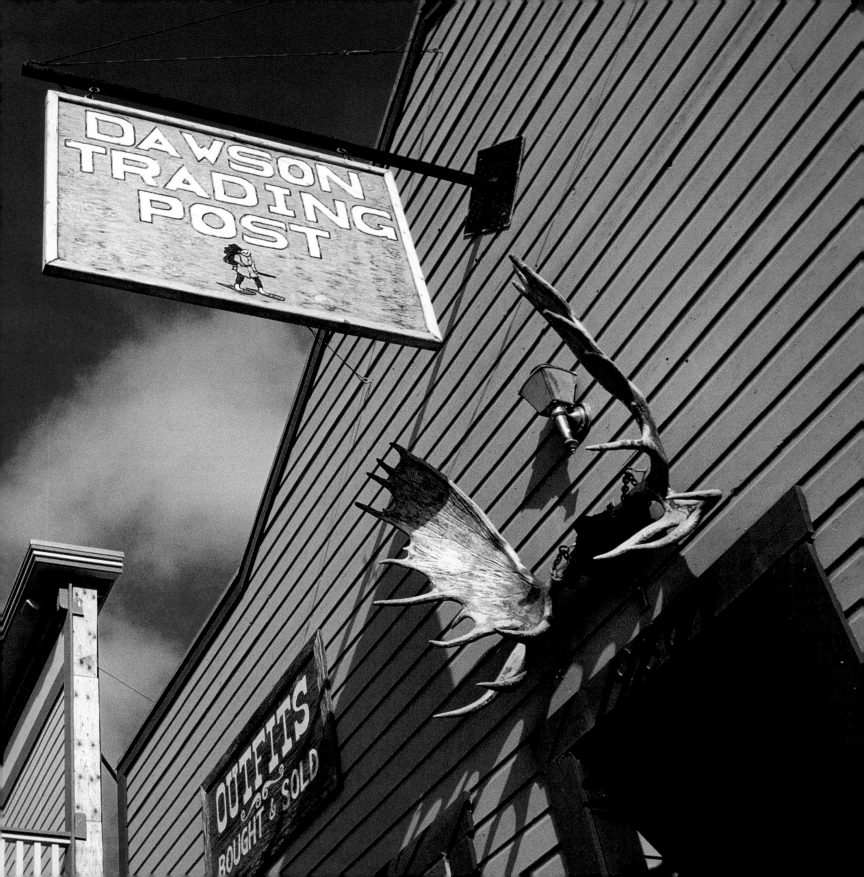

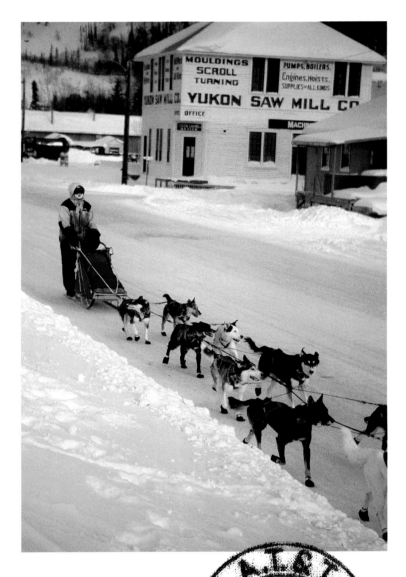

Zaack Steer, first runner-up in Yukon Quest 2004, pulls into Dawson after five days and 560 miles of sledding. After resting for thirty-six hours, he'll head for Whitehorse, 435 miles to the south.

Gold Fever

After their two-and-a-half-month journey from San Francisco, Jack London and his crew are finally nearing the Klondike River. In this race down the Yukon, they must contend with a stream of sailboats, rowboats, and birch-bark canoes also loaded with tons of prospecting equipment and provisions. It's a parade of madmen lost in the immensity of the Grand North, all of them determined to be first in the land of gold.

In mid-October 1897, after sailing nearly 450 miles, Jack and his friends reach Split-Up Island. The island is situated in the middle of the Yukon, some 80 miles upstream from Dawson City. Rumors are flying that the town, besieged by the army of gold seekers, has had such difficulty obtaining food that it is on the brink of starvation. The price of fresh vegetables is astronomical. As for the price of eggs, it beats all the records. Any man who can get a load of fresh eggs as far as Dawson is guaranteed to make his fortune!

Inflation is so high that the prospectors have soon emptied their pockets just to put food in their mouths, buy candles . . . or celebrate their success in the saloons. Even so, these are the lucky ones. Not only is it becoming virtually impossible for newcomers to find the precious yellow metal—it is almost impossible even to look for it. It appears that all the mining concessions have already been claimed!

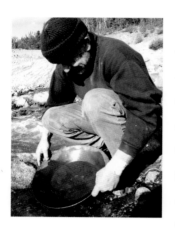

"No, I haven't got gold fever. For me it's the search for something that's hidden. To give you an example, it makes me just as happy to find morels. In the days of the 'old timers,' the generation between 1870 and 1900, a lot of miners would find a promising spot, then leave it when they heard rumors of another strike. They'd abandon everything just to make sure the grass wasn't greener somewhere else. You can see gold fever in certain people's eyes when they get their hands on gold. I've seen men whose whole physiognomy changes when you show them a nugget, no matter how small. I wouldn't say it's exactly lust you see in their eyes, but there is a craving to possess it. Gold fever is when someone will sacrifice everything to chase after a pipe dream. He'll spend his last penny, even if it means he has to borrow more just to keep chasing rainbows. I never got that bad. At least I've still got my head on my shoulders. That's what I think, anyway, but . . . no, it's not gold fever. Because once I find it, I have to keep looking elsewhere. . . ."

—Jean-Pierre Burlot, Yukon prospector for twenty years

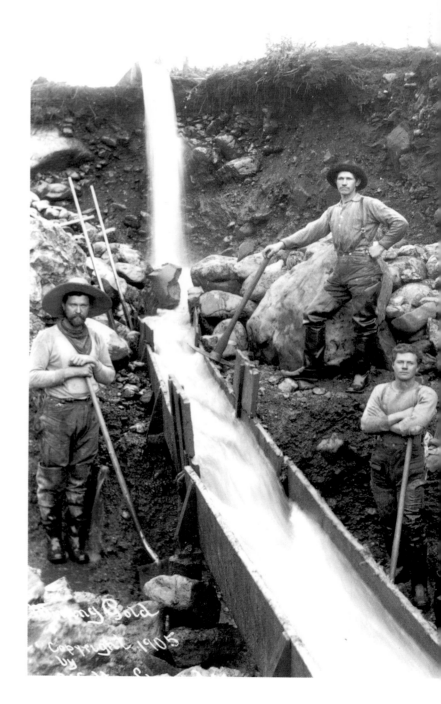

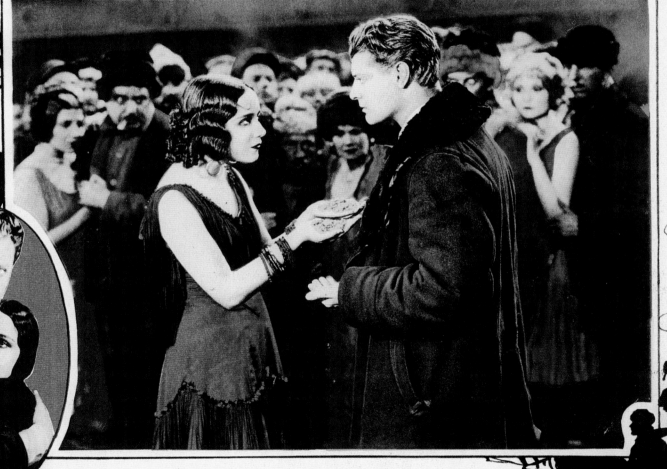

THE TRAIL OF '98

A **Metro-Goldwyn-Mayer** PICTURE

"You've found your gold—but you've lost me!"

MADE IN U.S.A.

Around the Bonanza Mine, where G. W. Carmack made the first great strike in August 1896, the Klondike River had become a vast minefield. On every scrap of land along its banks, prospectors turned over the gravel and dirt with shovels, leaving huge mounds. The debris was then put through the "sluice box," a long, open wooden trough raised at one end with a series of "riffles" or ridges across its floor. When the dirt and gravel were washed down the length of the sluice by a stream of water, the gold was trapped by the riffles and the mud washed out the lower end. Since the system is absolutely dependent on enormous quantities of water, a gigantic network of wooden channels was constructed to divert streams onto the concessions. Day and night, the men scraped and dug at the land like ants, transforming the Klondike into a colossal Swiss cheese. For those too late to obtain a concession there was only one choice: to get themselves hired by the new gold kings. Then at least there was some hope of repaying the costs of their adventure and buying themselves a ticket home.

Realizing that there's no room for him in Dawson, Jack decides to try his luck a short distance upriver on Henderson Creek, in one of the last regions remaining to be exploited. He scours the riverbanks for three days with the help of Jim, already an experienced placer miner. Jack pans from dawn to dusk, his feet in freezing water. Gradually he gets the hang of the famous circular motion that leaves the heavy ore in the bottom of the large metal pan. Little by little, the first specks of gold dust appear. A few grains of precious yellow sand shine in the soft autumn light.

It is mid-October and the days are swiftly growing shorter. Each day the sun sets seven minutes earlier; every week they lose more than forty-five more minutes of light. The great darkness of winter is rapidly descending on them, and sometimes Jack has to light a match just to see his lucky find.

After numerous attempts in various spots, Jack thinks he's found a vein. This will be his claim. He marks it off with four stakes in which he's carved his name with a pocket knife. Now all he needs to do is register it in the Mining Recorder's Office in Dawson.

In December 1898 Jack London registered his concession in the Mining Recorder's Office in Dawson. You can do likewise today. Ten dollars will buy you the right to look for gold on a plot of land for one year.

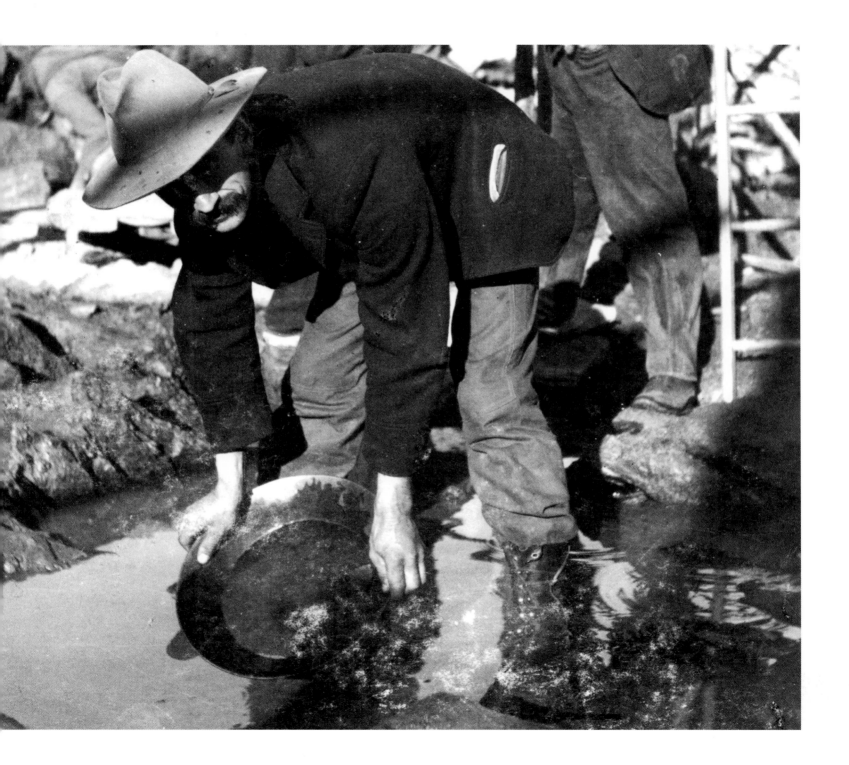

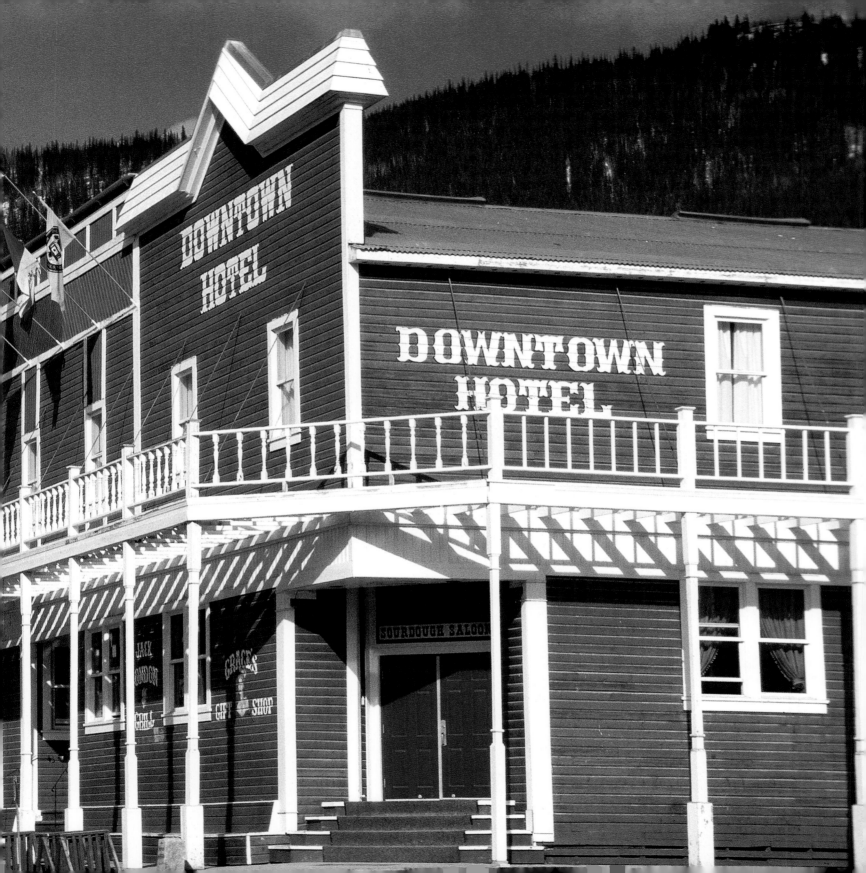

Dawson Follies

After a three-day trip down the Yukon, Jack made his debut in the "Paris of the North," otherwise known as Dawson. So many small boats were tied up on the river-banks that you'd have thought you were in a port in the Orient. The streets of this mushrooming town were packed with a rowdy throng of prospectors, horses—and dogs. Dogs were there in great numbers, as they were the principal draught animals: huskies, malamutes, shepherds, wolfhounds, and even domesticated wolves.

With the arrival of winter came the time to buy your team. Whether you favored Indian dogs or dogs imported from the West Coast of the United States, there were dogs for every taste. Negotiating, trading, and haggling were conducted in every tongue amid a deafening concert of barking. Off to the side dog fights were being organized, to the delight of the gamblers exchanging bags of gold dust.

Dawson, which had consisted of four trappers' cabins the year before, has become a gigantic bazaar. The immense camp of tents is giving way to wooden houses with colorful façades, joined by saloons and hotels—a genuine town. At the height of the Gold Rush, Dawson will boast more than 25,000 inhabitants, making it the largest Canadian city west of Winnipeg.

At the time Jack arrives, however, the atmosphere is rather tense. It's the onset of winter and, as the population never stops growing, food and other supplies are getting scarce.

The Gold Rush transforms Dawson into a mecca of pleasure, complete with hotels, saloons, casinos, and even an opera. The wild explosion of luxury earns Dawson the title "Paris of the North."

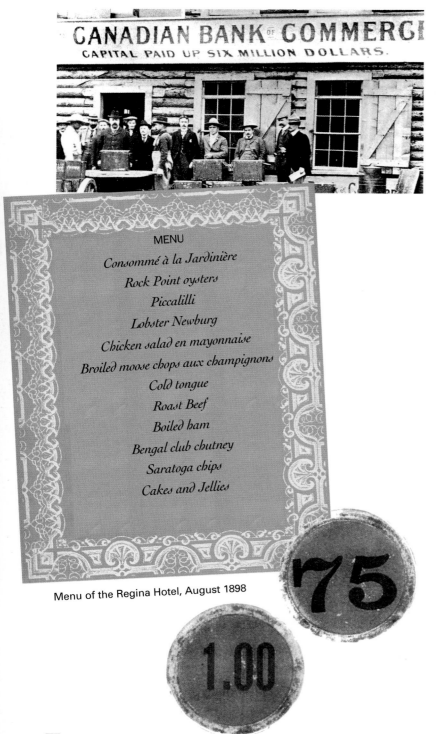

MENU

Consommé à la Jardinière

Rock Point oysters

Piccalilli

Lobster Newburg

Chicken salad en mayonnaise

Broiled moose chops aux champignons

Cold tongue

Roast Beef

Boiled ham

Bengal club chutney

Saratoga chips

Cakes and Jellies

Menu of the Regina Hotel, August 1898

The prospectors were not the only winners in this lunatic race. Purveyors of prospecting equipment and foodstuffs rapidly became the new lords of the realm. Dawson was so isolated that prices for staple items skyrocketed, quickly making it the most expensive town in North America. Gold dust and nuggets were the medium of exchange, even for buying a pound of flour. Eggs were $1.00 apiece—at a time when the average worker in the United States earned just $1.50 a day! A gallon of milk fetched $30, which was five times the price of whiskey.

Dawson may have been short of food, but the banks were multiplying. They scooped up the prospectors' gold at $16 an ounce and converted it to ingots. The Bank of North America, the Bank of Commerce, and more . . . Business was booming. Soon the city also boasted two daily newspapers and a telegraph service. Some gold kings such as "Big Alex" were so hungry for news that they paid $50 in gold for one paper!

In 1898 thirty transport companies ran more than sixty steamboats. Stores sold equipment and clothing. There were commercial photographers. You could even buy yourself some gold teeth, or a massage!

And of course these new bachelor millionaires out in the middle of nowhere had to be entertained. Casinos, bars, and cabarets sprung up everywhere, bearing evocative names like "The Monte Carlo," "The Eldorado," "The Moosehorn," and "The Tivoli." They offered the prospectors a chance to drink, to dance, and to forget winter and the hard labor of mining.

The years 1897 to 1900: the Gay Nineties . . . Grand North-style!

Seemingly in no great hurry to find gold, Jack London takes his time registering his concession in the Recorder's Office and devotes himself to enjoying Dawson. For six weeks he makes the rounds of the bars and listens to the crazy tales of all the "gold kings." When the sun goes down, the kings can be found with their "courts" of bearded Klondikers in beaver-skin hats knocking back glasses of whiskey at $5.00 a shot.

They sing and roar with laughter against the sound of pianos and violins. Or they pay a visit to "Paradise Alley" or "Hell's Half-Acre" in the red-light district. The never-ending stream of men pouring into the town brings an explosion in prostitution. Women flock to Dawson City to make their fortunes in their own way.

The Dawson madness reaches its zenith with the construction of the Opera House, the scene of numerous masked balls. It is there that the celebrated dancer Freda Moloof, who bills herself as the "Turkish Whirlwind Danseuse," will perform her famous number, driving more than one man mad.

In 1898, thanks to the burgeoning steamboat traffic, luxury assumes delirious proportions. They say, for example, that David Doig, the new manager of the Bank of British North America, deprived himself of nothing, parading up and down Main Street in a very British flannel suit and felt hat. His hobbies were whiskey, cigars, and women, and he dined on foie gras, oysters, and caviar. Breakfast was inconceivable without his pint of champagne!

Deep in the heart of the northern forest, just a few miles from the Arctic Circle, Dawson became the city of every pleasure and every folly.

DAWSON CITY
GENERAL STORE

J.R. DALTON
GENERAL MERCHANT

WHITNEY & PEDLAR
GENERAL
MERCHANDISE.

"Where is Freda?" the Old-Timers questioned, while the che-cha-quas were equally energetic in asking who Freda was. The ballroom buzzed with her name. It was on everybody's lips. Grizzled "sour-dough boys," day-laborers at the mines but proud of their degree, either patronized the spruce-looking tenderfeet and lied eloquently [. . .] or gave them savage looks of indignation because of their ignorance. Perhaps forty kings of the Upper and Lower Countries were on the floor, each deeming himself hot on the trail and sturdily backing his judgment with the yellow dust of the realm. An assistant was sent to the man at the scales, upon whom had fallen the burden of weighing up the sacks, while several of the gamblers [. . .] made up alluring books on the field and favorites. Which was Freda? Time and again the Greek dancer was thought to have been discovered, but each discovery brought panic to the betting ring and a frantic registering of new wagers by those who wished to hedge.

The Klondike Gold Rush

With a good swing

1. Oh, come to the place where they struck it
2. Oh, they scrat-ches the earth and it tum-bles

rich, Come where the trea-sure lies hid Where you hat full of mud is a
out. More than your hands can hold, For the hills a - bove and the

GASLIGHT FOLLIES

CELEBRATING THE 100TH ANNIVERSARY OF
THE PALACE GRAND THEATRE
A National Historic Site

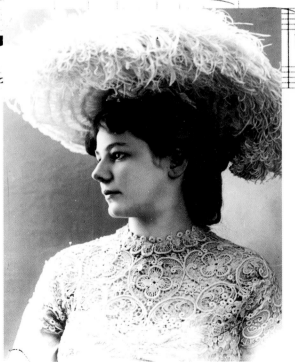

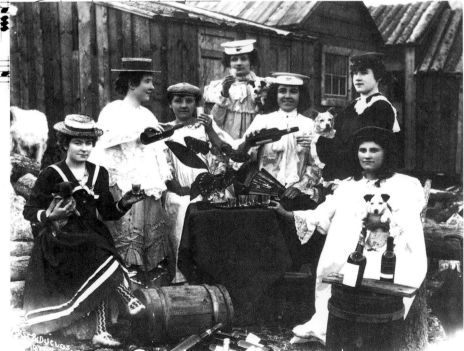

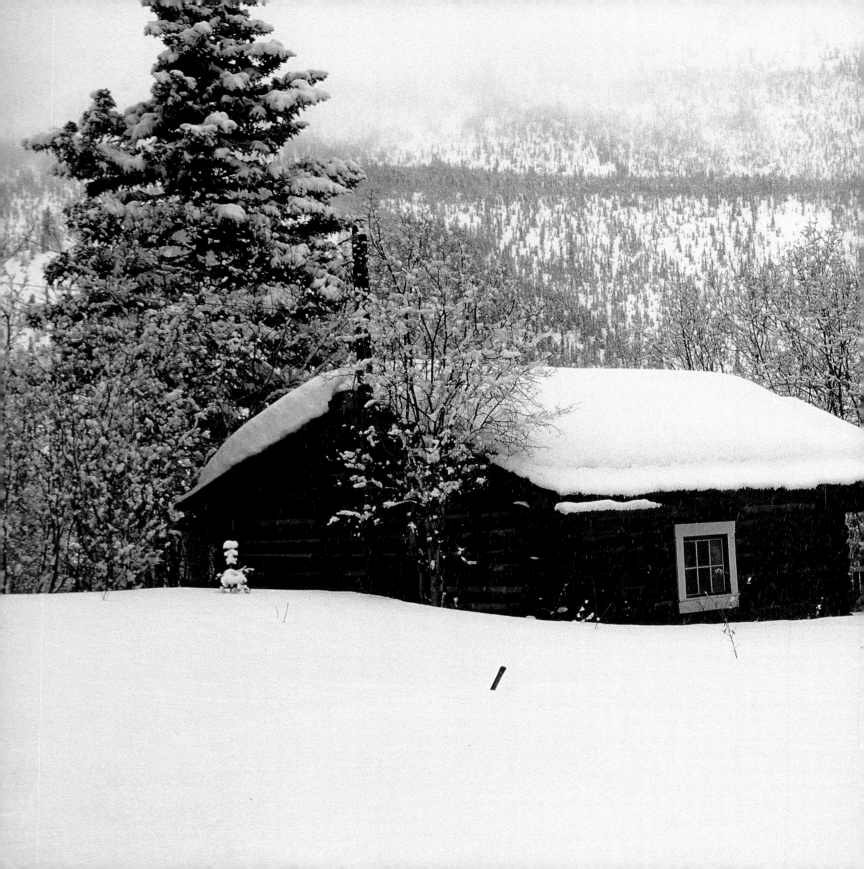

Northern Fever

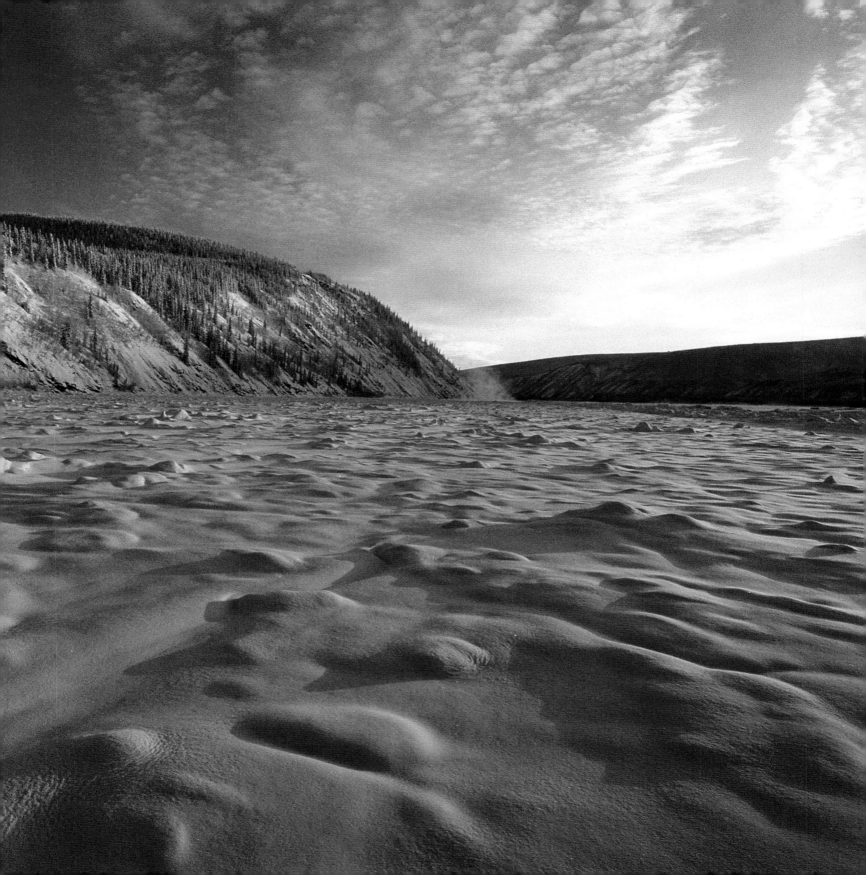

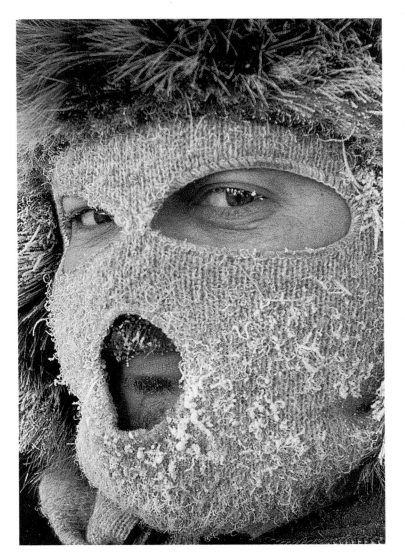

Fever and Chills

After a month of reveling in the wild life of Dawson, Jack finally registered his concession, which bore the number 54. For the sum of $25, the Mining Recorder's Office granted him the right to look for gold on his parcel of land for one year.

Jack and Fred head back to Henderson Creek, where Sloper, Jim, and the others were already settled in. Winter, too, had settled in, and there was no longer any question of sailing the *Yukon Belle*, as the river was frozen solid. They are left with no choice but to hike upriver on its frozen surface. Their two silhouettes, bulky with layers of clothing and bowed against the glacial wind, advance slowly over the boundless white wasteland. Their progress is erratic and their course rarely straight as they must pick their way between the great blocks of ice formed by the giant waterway.

They have been walking for two days now and the blizzard hasn't shown any sign of dying down. The temperature must be approaching minus forty and their fingertips are growing numb—the first sign of frostbite. Suddenly, Fred stops short, a pool of water right in front of him. It was a close save. Falling into that water would have meant hypothermia and instant death.

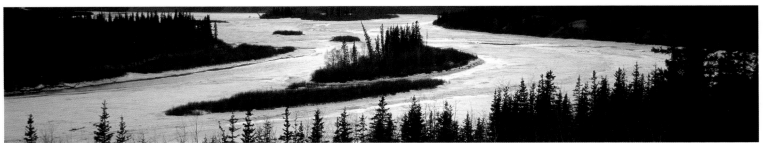

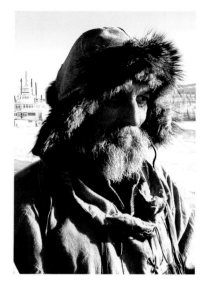

"There was a guy here a few years ago who took all his clothes off and jumped into the lake. And that is where they found him in the next spring. He must have had some kind of hypothermia and when you have hypothermia and you start feeling warm, you actually believe that you are hot. So you start getting your clothes off because the colder you get, the hotter you feel. You are actually freezing to death but you feel super hot. That's the last stage of hypothermia, and you have to be able to recognize that. You have to stop, build a fire, and get back to where you came from."

—Norman Winther, trapper for thirty years near Ross River in the Yukon (February 2004)

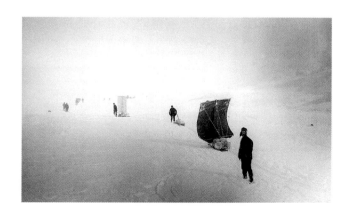

In conditions this extreme, a little ingenuity can save your life. Here, in the midst of a blizzard, some clever souls are sailing their merchandise over White Pass on sleds.

PIONEERS

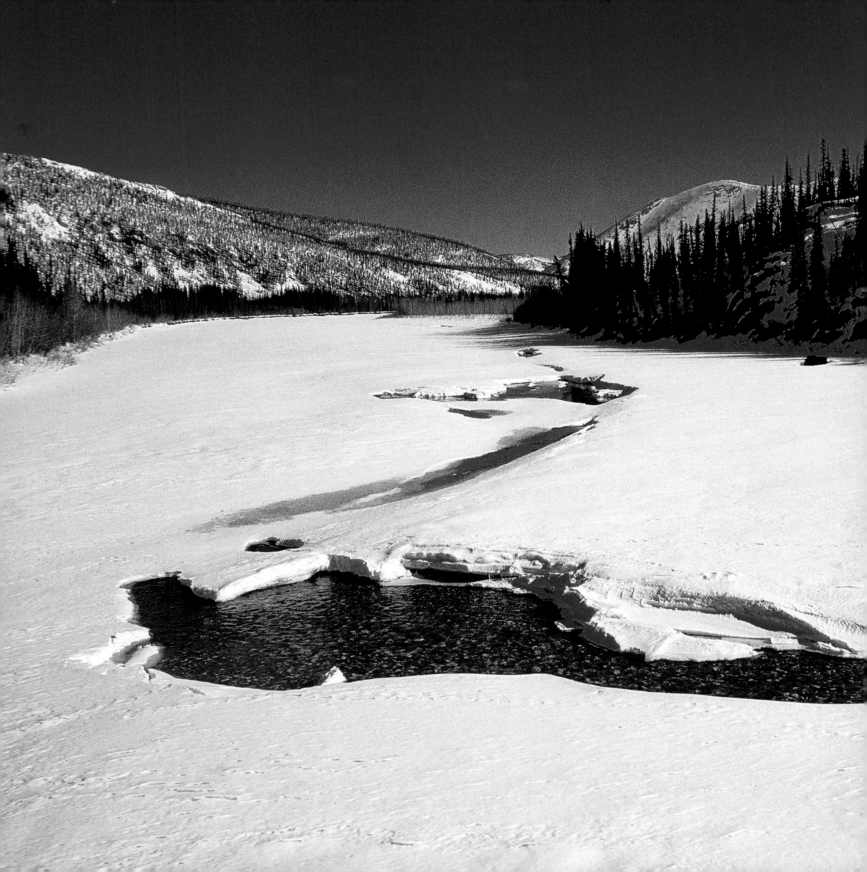

Cabin fever

After four days of walking, the two weary men finally reach Henderson Creek. At last—the warmth of the log cabin with a fire crackling in its big stove! Their faces plunged into their tin plates, Jack and Fred devour mountains of baked beans while they recount their adventures. Nothing quite like a bit of human warmth to bring you back to life! And with six men living in the little trapper's cabin, there's human warmth to spare.

Naturally the talk soon turns to gold. But with temperatures approaching minus fifty degrees Celsius and the ground frozen several yards deep, they don't spend a lot of time thinking about looking for it. There's nothing to do but the daily chores of living: collecting blocks of ice from the nearest stream to melt on the stove, chopping wood, shoveling the snow away from the door. And cooking, of course. Preparing the "three Bs"—beans, bread, and bacon, the classic prospector's menu—in every form imaginable.

A routine sets in, simple and monotonous, day after day. To pass the time, they smoke, they read, they play cards . . . and they tell stories. Throughout the long Klondike winter, Jack soaks up stories about trappers, French-Canadian woodsmen, prospectors, Indians . . .

But a winter spent with five other men in a single, stuffy, smoke-filled room can wear thin fairly quickly. The pretty cabin deep in the forest soon becomes a wooden prison. One after another, the men began to find each other's company, the idleness, and the oppressive darkness unbearable.

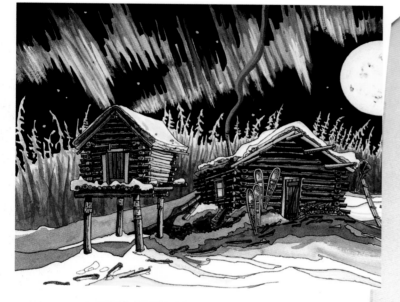

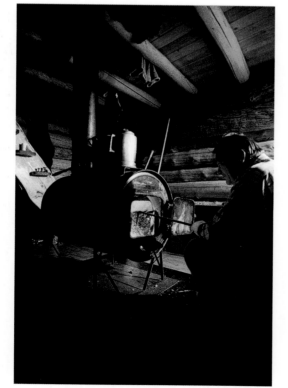

[. . .] the little cabin crowded them—beds, stove, table, and all—into a space of ten by twelve. The very presence of either became a personal affront to the other, and they lapsed into sullen silences which increased in length and strength as the days went by. Occasionally, the flash of an eye or the curl of a lip got the better of them, though they strove to wholly ignore each other during these mute periods. And a great wonder sprang up in the breast of each, as to how God had ever come to create the other.

With little to do, time became an intolerable burden to them. This naturally made them still lazier. They sank into a physical lethargy which there was no escaping, and which made them rebel at the performance of the smallest chore.

[. . .] Next, their muscles and joints began to swell, the flesh turning black, while their mouths, gums, and lips took on the color of rich cream. Instead of being drawn together by their misery, each gloated over the other's symptoms as the scurvy took its course.

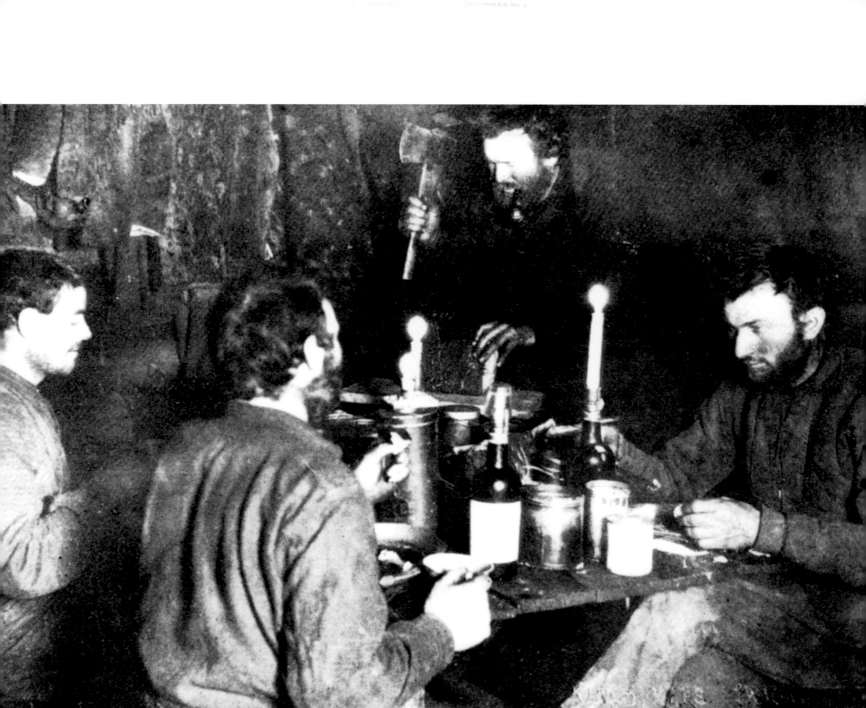

In the Grand North there's a lot of talk about "cabin fever." It's a syndrome as well-known as mountain sickness or the diver's "rapture of the deep." Trappers and prospectors fear it like the plague. It can lead to madness, and there are countless stories of men who have murdered their cabin mates after a few months of winter.

When Jack first rejoins his companions, he is overjoyed. Getting reacquainted and listening to the stories of the neighboring cabin dwellers delights him. But one month later he has had enough.

Tension has been mounting, and clashes are becoming more frequent. One day Jack goes out to cut wood and, without bothering to ask, borrows the axe of Merritt Sloper, the carpenter of the group. In a clumsy swing he hits a rock with the blade. Sloper goes crazy, yelling, "Who do you think you are, you pirate! I'll have your hide for this!" Sloper reaches for his rifle, but Fred and Jim eventually manage to restrain him.

Following Sloper's fit of rage, Jack moves out.

To discourage hungry bears, food reserves are kept in a pantry inside a cache perched on tall metal-covered stilts.

Cabin by Lake + Beach

"Two old guys had been trapping together for years and they shared a main trapline cabin. One used to trap to the north and the other one would trap south. And when they would meet they would be in the main cabin. They would not see each other for days. And one day that they were out there, and there must have been something going on. I am not sure what was said, but one guy took his rifle and shot the other guy because he had hung the frying pan on the wrong nail of the cabin! Killed him dead. So there was obviously something bothering them both, and one guy just caught the cabin fever. He could not stand his partner no more."

—Norman Winther

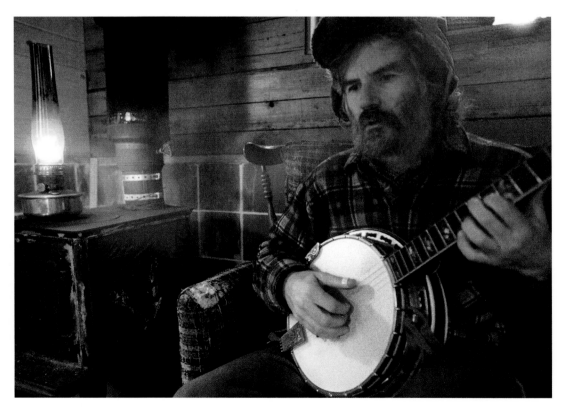

Eric Holle on the banjo in his log cabin near the Chilkat River.

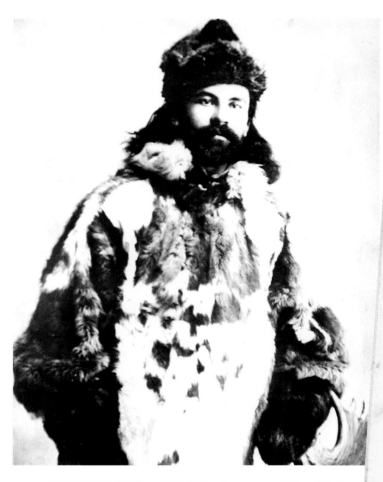

What with the Fear of the North, the mental strain, and the ravages of the disease, they lost all semblance of humanity, taking on the appearance of wild beasts, hunted and desperate. Their cheeks and noses, as an aftermath of the freezing, had turned black. Their frozen toes had begun to drop away at the first and second joints. Every movement brought pain, but the fire box was insatiable, wringing a ransom of torture from their miserable bodies. Day in, day out, it demanded its food,—a veritable pound of flesh,—and they dragged themselves into the forest to chop wood on their knees. Once, crawling thus in search of dry sticks, unknown to each other they entered a thicket from opposite sides. Suddenly, without warning, two peering death's-heads confronted each other. Suffering had so transformed them that recognition was impossible. They sprang to their feet, shrieking with terror, and dashed away on their mangled stumps; and falling at the cabin door, they clawed and scratched like demons till they discovered their mistake.

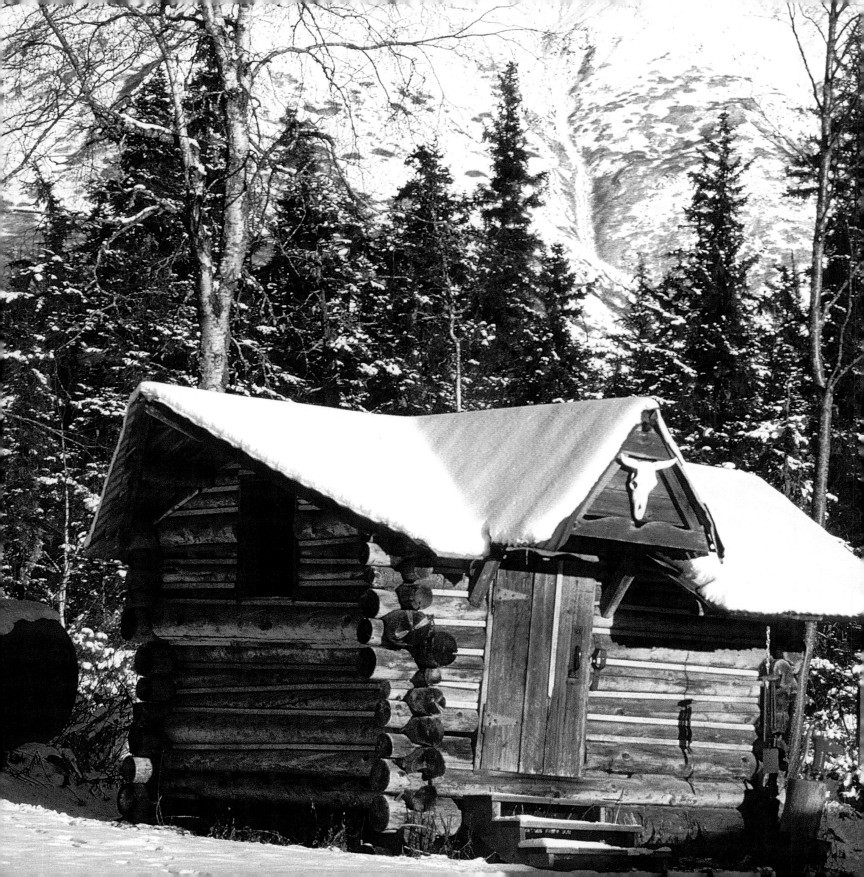

There is no going back on his decision. Jack installs himself in the cabin of Doc Charley, an alcoholic surgeon who has come to the Klondike to dry out, and Sullivan, a judge turned adventurer. These two renegades from high society, two bourgeois capitalists in search of themselves, are suddenly confronted with a "worker-pirate-vagabond" from the poorest neighborhoods of San Francisco who is determined to become a writer.

Conversation around the stove in the little house is lively. Despite the fatigue brought on by his scurvy, Jack can still summon up the passion to try to convert his companions to socialism! But this energy fades quickly, for the disease soon gets the upper hand.

The secret to surviving the long winter with its extreme temperatures and scanty hours of daylight is to keep busy. Shovel snow, chop wood for the cabin stove, break up the ice in the stream nearby. Turn the simplest household task into an undertaking that must be carefully planned and orchestrated. This protects the mind from cabin fever.

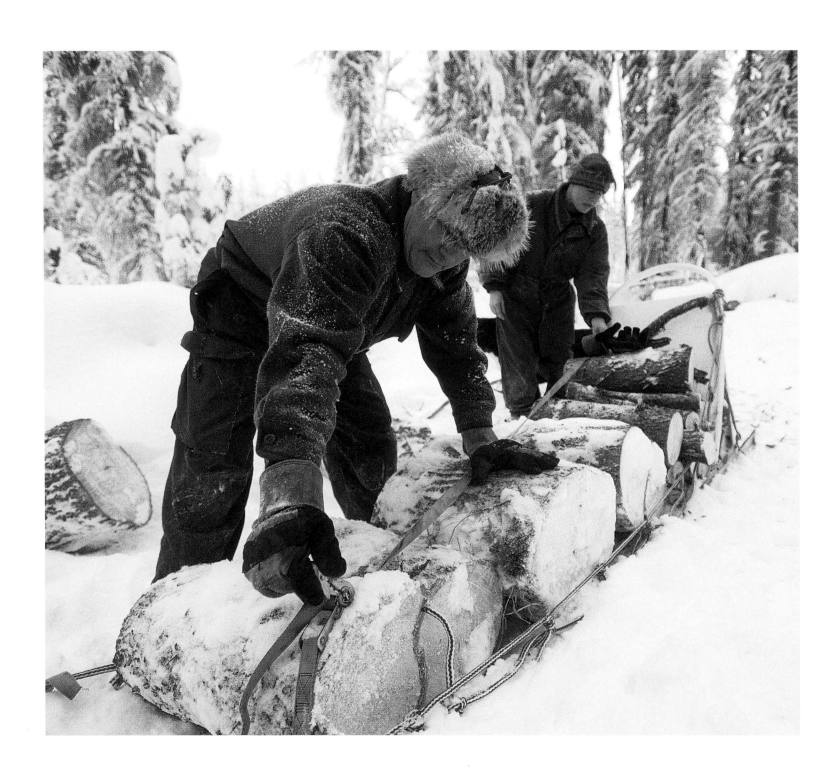

"The main thing about living in a cabin like this and being by yourself, the hardest part of it, of the whole life actually, is facing yourself. There is nobody else to blame for your mistakes. There is nobody else around. Whatever goes wrong, whatever you have to face—you are the one. As soon as you can face yourself, if you can get up and look at yourself in the mirror and you like what you see, then you come to terms with yourself. And that is the basis of living by yourself in a bush cabin. There's a lot of people in the world that every time something goes wrong, they blame the government, their neighbors, they blame anything but never, ever blame themselves. And if they blame themselves once in while, if they look at themselves, they might find out that those neighbors and them could get along if they would only meet them halfway. So, you have to blame yourself when something goes wrong in the bush, there is nobody else."

—Norman Winther

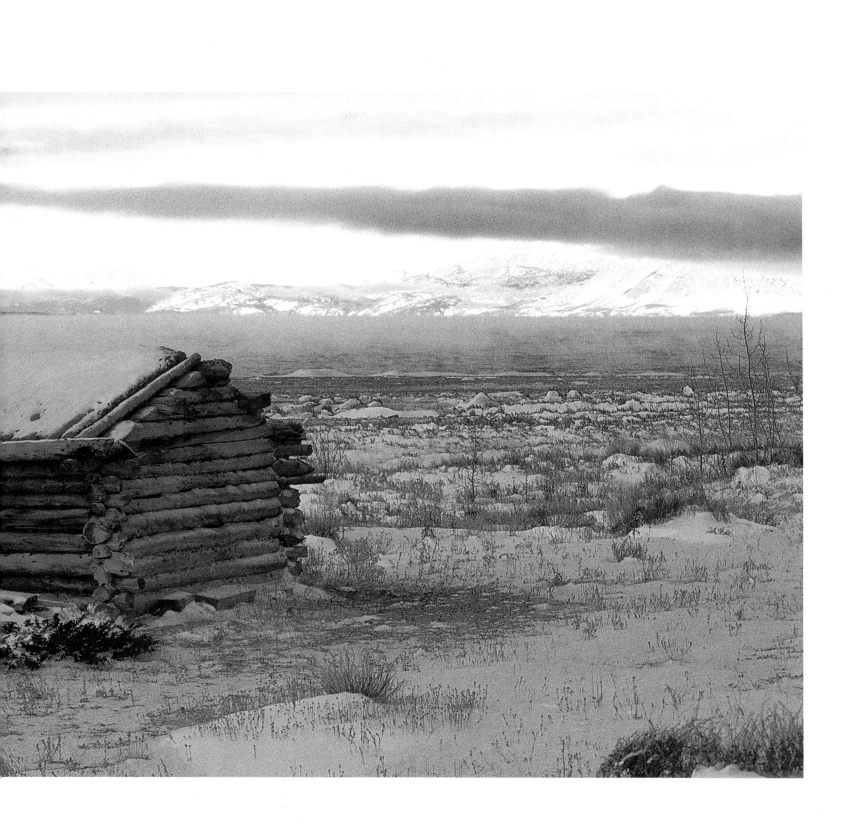

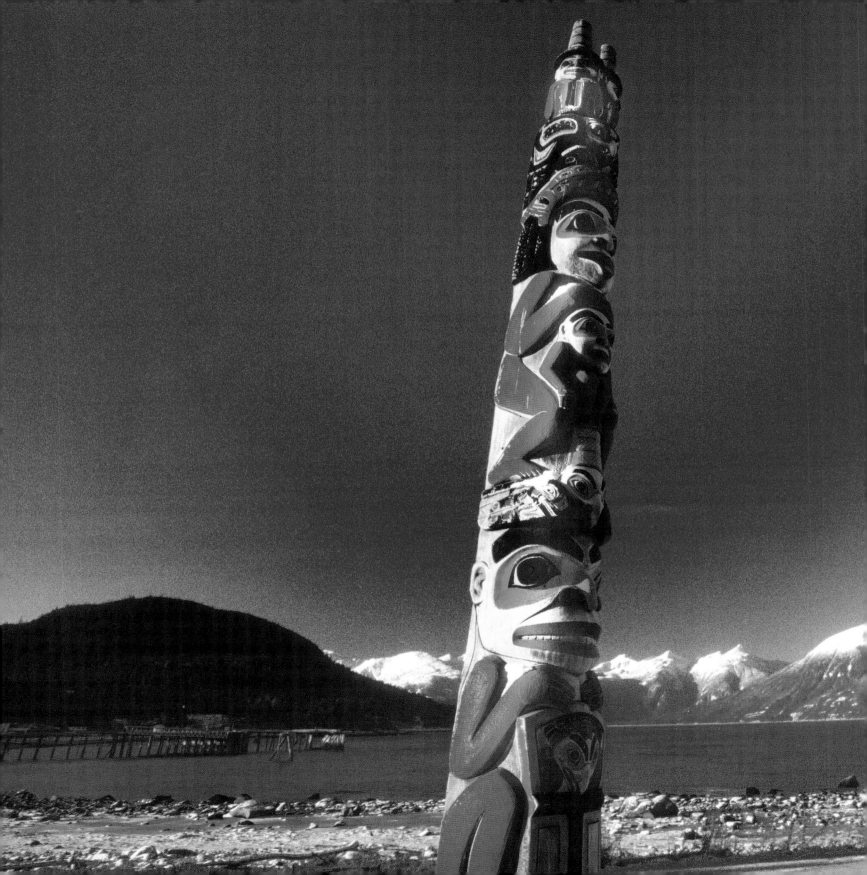

Children of the Frost

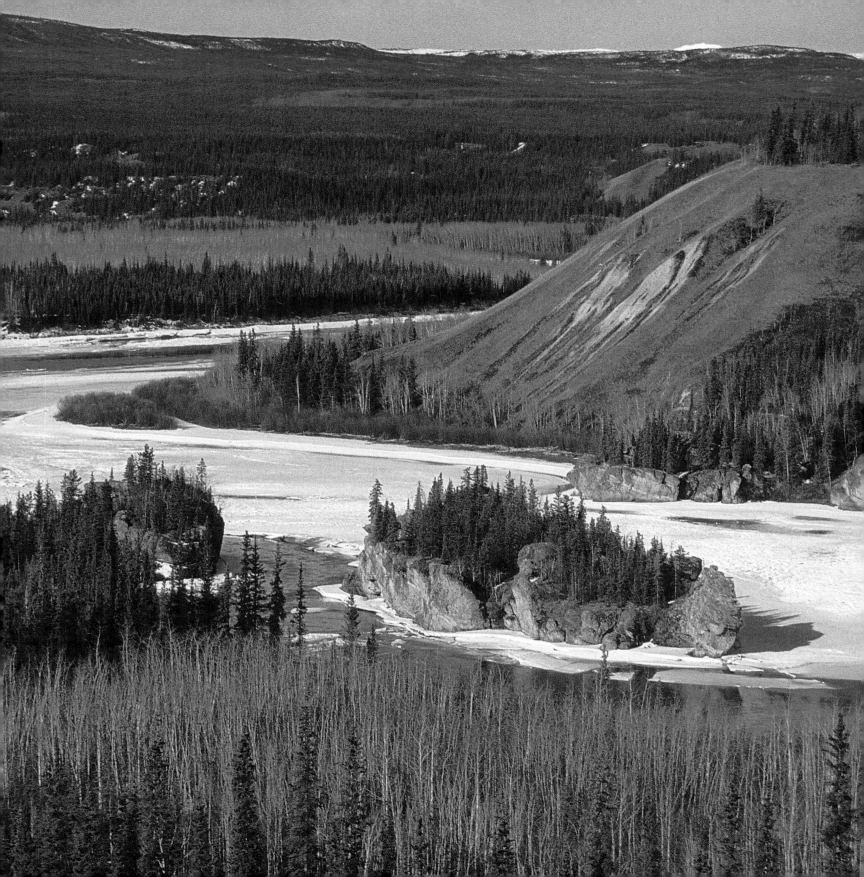

Compelled to Leave

By May 1898 scurvy has sapped Jack's strength. His teeth are loose, his skin is dry, and his joints make him scream with pain. But he isn't alone in his suffereing; most of the prospectors on Split-Up Island and along Henderson Creek have some of these symptoms. Doc Charley, the retired doctor with whom Jack shares the cabin, advises him to get himself taken care of in Dawson as soon as he can. Jack finally chooses this path of reason. In any case, he is ready to abandon his concession. According to the old-timers, it doesn't look all that promising.

Although Jack's decision to leave has been made, he must first wait for the Yukon to thaw. Huge blocks of ice are beginning to break off the banks under the warmth of the spring sun. Since the winter solstice, the days have been growing longer as quickly as they shrank—seven more minutes of light every day. It is early May and the sun doesn't go down before 10:00 P.M. On June 21 it will not set at all.

The river is cracking and breaking up, but only a fool would attempt to sail it before it thaws completely, around the end of May. Meanwhile, Jack is building a new boat with Doc Charley. It is brutal work for a man weak and exhausted with scurvy. A number of other prospectors also decide to leave Split-Up Island. It is common knowledge that during "break-up," the ice blocks swept along by the river are inclined to smash chunks off the little islands in their path and sometimes wipe them completely off the map. Eventually the blocks will crash against the banks and pile up in a giant, ever-expanding puzzle.

In Dawson, Jack stays in the cabin of the Bond brothers. A few years later he will draw his inspiration for Buck, the hero of *The Call of the Wild*, from their dog. Despite the care Jack receives at St. Mary's Hospital, he is not cured. Food is still in such short supply in Dawson that it seems impossible to get a sufficient daily amount of vitamin C. After several weeks he is advised to go home to San Francisco as soon as he can. On June 8, accompanied by Charles Taylor and John Thorson, Jack sets out on the 1,800-mile journey down the Yukon to its mouth at St. Michael on the Bering Sea.

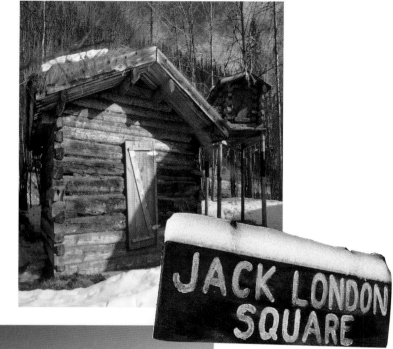

In the spring of 1898, Jack London, with crippled limbs and almost incapacitated, leaves the log cabin and returns to Dawson City for medical treatment. With the thaw, the tundra reappears on the arctic plateaus and so does the ceaseless coming and going of small craft and steamboats in Dawson's port. The front door to the Grand North, as well as the back, is open again!

92

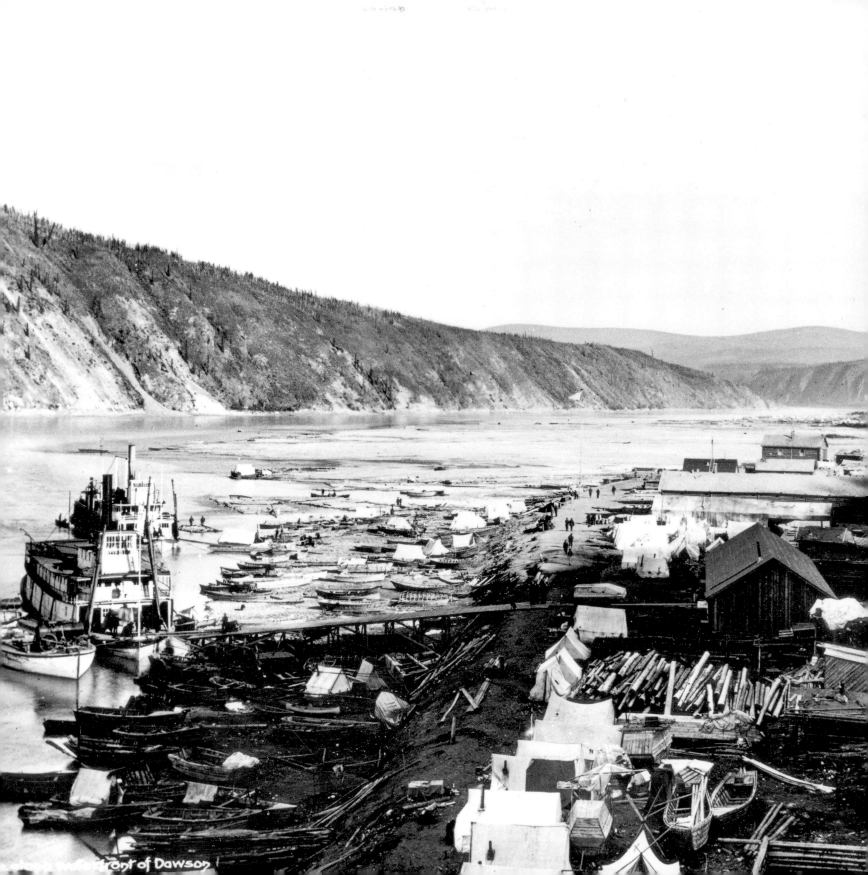
front of Dawson

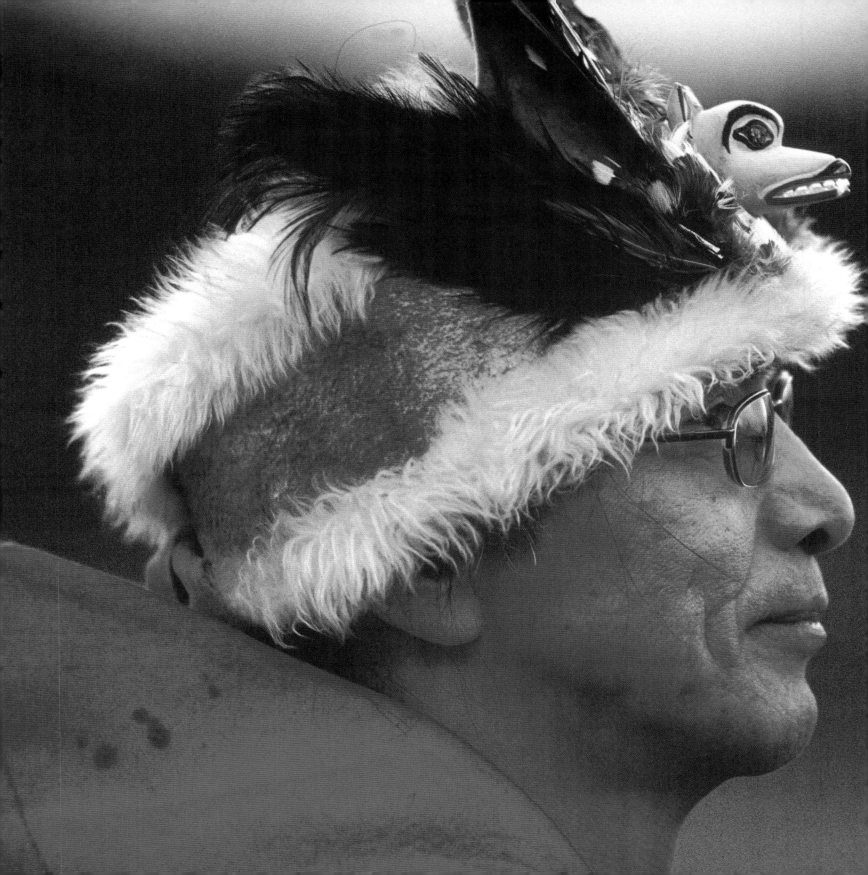

Sons of the Great Land

The river sets its own pace, and it takes Jack and his comrades more than three weeks to cross Alaska—aptly named, for *Alaska* means "the Great Land" in the language of the Athabascan Indians. Lying on a large folded canvas in the bottom of the boat, Jack bears his illness patiently.

There have always been many Indian communities along the banks of the Yukon, this powerful communication route gliding straight through impenetrable forests. As the three men sail from one encampment to the next, the Indians' tales are added to Jack's hoard of prospectors' and trappers' stories.

He had been meeting Indians since he first set foot in Juneau and hired their services to canoe to Dyea Beach. On the trek over Chilkoot Pass, many natives were paid to carry tons of equipment and supplies for the thousands of white men from California. Jack met others during his visits to Dawson, where the promise of wealth lured the young men of the region's tribes.

Around the fire in the teepees, Jack listened to the old chiefs, nomads and hunters who are as one with the Grand North. They spoke of the unusually harsh winter that was drawing to a close. They talked about the recent thaw and looked forward to the return of the salmon, hoping that the fishing would be good enough to feed the dogs for the rest of the winter. The migration of the caribou should be later this year, Jack considered; the Indians will have to walk much farther toward the great frozen sea to hunt them. Here life is lived to the rhythm of the elements. The tempo of its music must be obeyed until death, for its law is implacable.

Throughout this long journey, Jack discovers the great diversity of the Amerindian peoples. He meets the Tlingits of the sea and damp forests, peerless sailors and sculptors; the Athabascans of the interior, kings of the rivers and the bush; even the Eskimos of the vast arctic plateaus and the shores of the Bering Sea. They are blood brothers but also mortal enemies who have waged war against each other since the dawn of time.

He bowed his head in content till the last noise of the complaining snow had died away, and he knew his son was beyond recall. Then his hand crept out in haste to the wood. It alone stood between him and the eternity that yawned in upon him. At last the measure of his life was a handful of faggots. One by one they would go to feed the fire, and just so, step by step, death would creep upon him. When the last stick had surrendered up its heat, the frost would begin to gather strength. First his feet would yield, then his hands; and the numbness would travel, slowly, from the extremities to the body. His head would fall forward upon his knees, and he would rest. It was easy. All men must die.

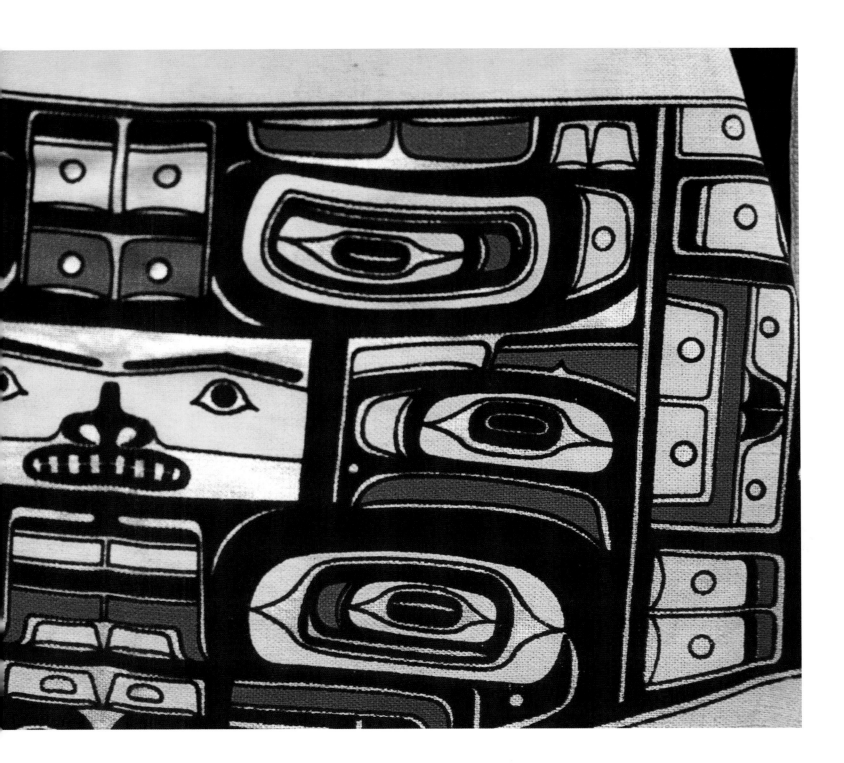

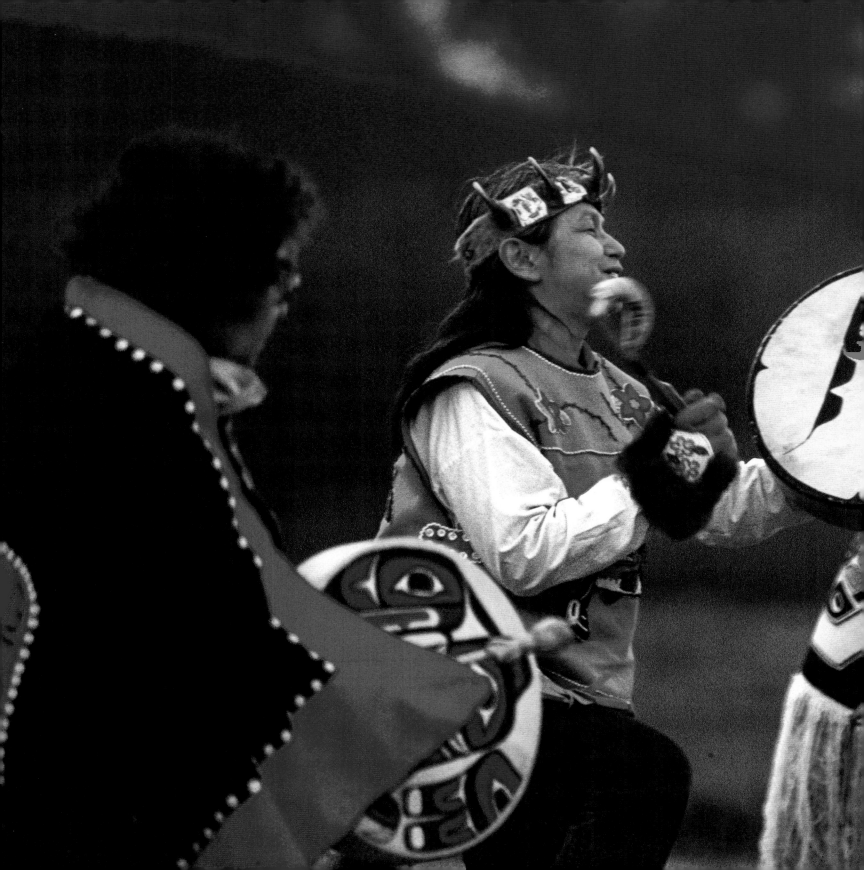

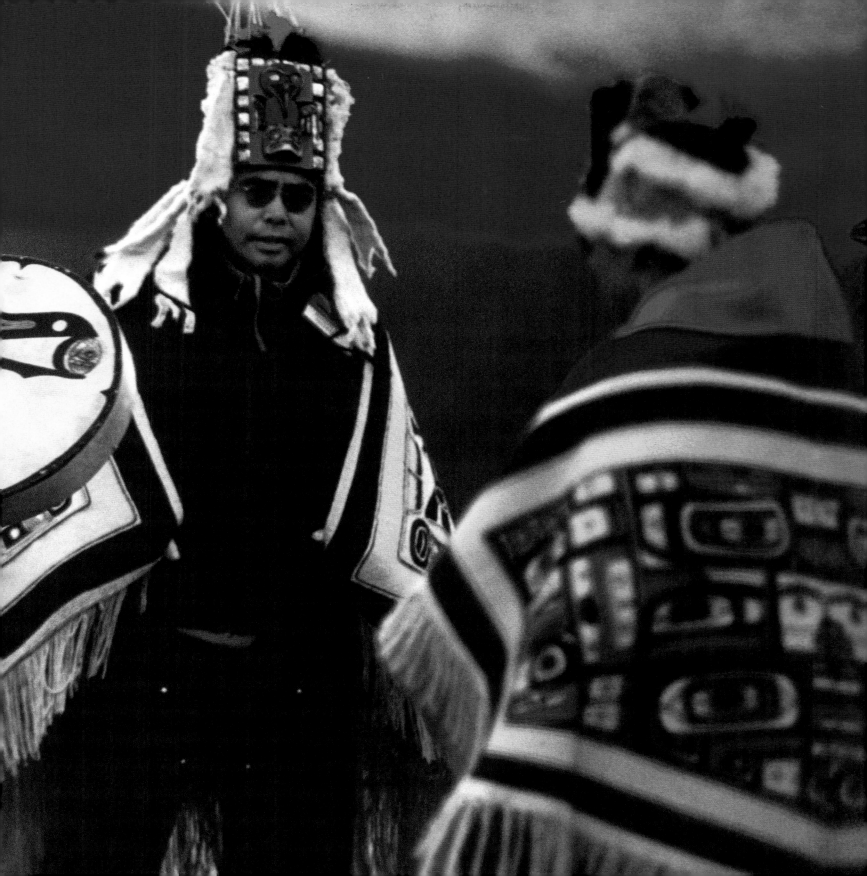

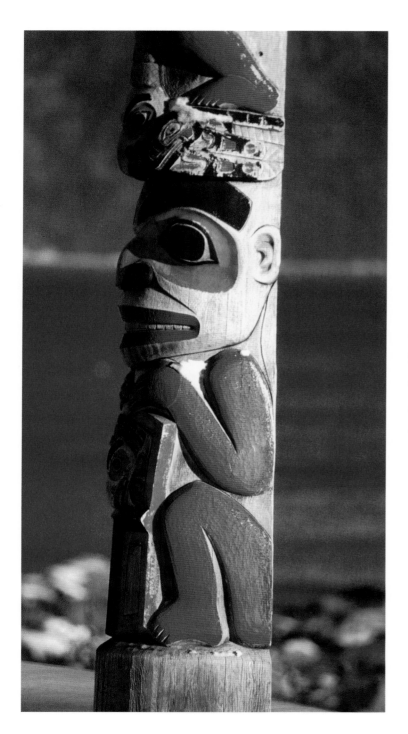

To affirm and reinforce their power, tribal chiefs regularly hold *potlatches*, great ceremonial feasts at which their riches are exhibited for all to see before being destroyed, passed along to heirs, or distributed among their guests. The rituals are also a means of settling conflicts between clans and resolving rivalries between chiefs, the victor being he who destroys the largest possible number of his possessions. Every bit of property ruined is meticulously counted, for tradition dictates that the guests or humiliated chiefs must return like for like. Preparations are made all winter. New houses and new canoes are built and, most importantly, towering totems are erected. These totems are adorned with brightly colored paintings of stylized animals symbolizing the chief and his family and celebrating their social rank. The more potlatches there are, the greater the delusions of grandeur. The totem poles must be taller and taller, the colors brighter and brighter, the gifts more and more precious—to the point, sometimes, of ruining the host.

And when he was very old, being greatest of chiefs and richest of men, he gave a potlatch. Never was there such a potlatch. Five hundred canoes were lined against the river bank, and in each canoe there came not less than ten of men and women. Eight tribes were there; from the first and oldest man to the last and youngest babe were they there. And then there were men from far-distant tribes, great travellers and seekers who had heard of the potlatch of Ligoun. And for the length of seven days they filled their bellies with his meat and drink. Eight thousand blankets did he give to them, as I well know, for who but I kept the tally and apportioned according to degree and rank? And in the end Ligoun was a poor man; but his name was on all men's lips, and the other chiefs gritted their teeth in envy that he should be so great.

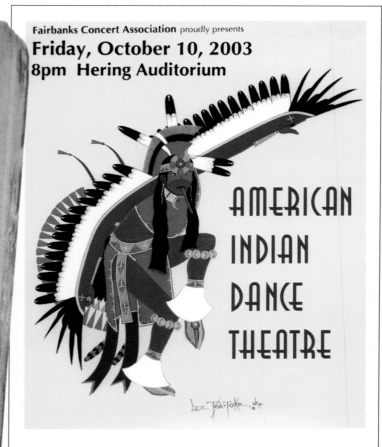

Fairbanks Concert Association proudly presents
Friday, October 10, 2003
8pm Hering Auditorium

AMERICAN INDIAN DANCE THEATRE

Lee Tsa Toke Jr.

Tickets: **$28 adults/$23 students, seniors, military (plus outlet fee)**
At Hoitt's Music, Safeway stores or call 1-800-478-7328

 Fairbanks Concert Association's programs are supported, in part, with funds provided by TourWest, the Western States Arts Federation, the Alaska State Council on the Arts, the City of Fairbanks through the Fairbanks Arts Association's re-grant process.

WESTAF A TourWest Program. This project received support from the Washington State Arts Commission; WESTAF - Western States Arts Federation; and the National Endowment for the Arts.

NATIONAL ENDOWMENT FOR THE ARTS

At the end of October, near Haines on the Pacific coast of Alaska, the Tlingit tribe celebrates the migration of the bald eagle (*pygargue*) with dancing and traditional ceremonies.

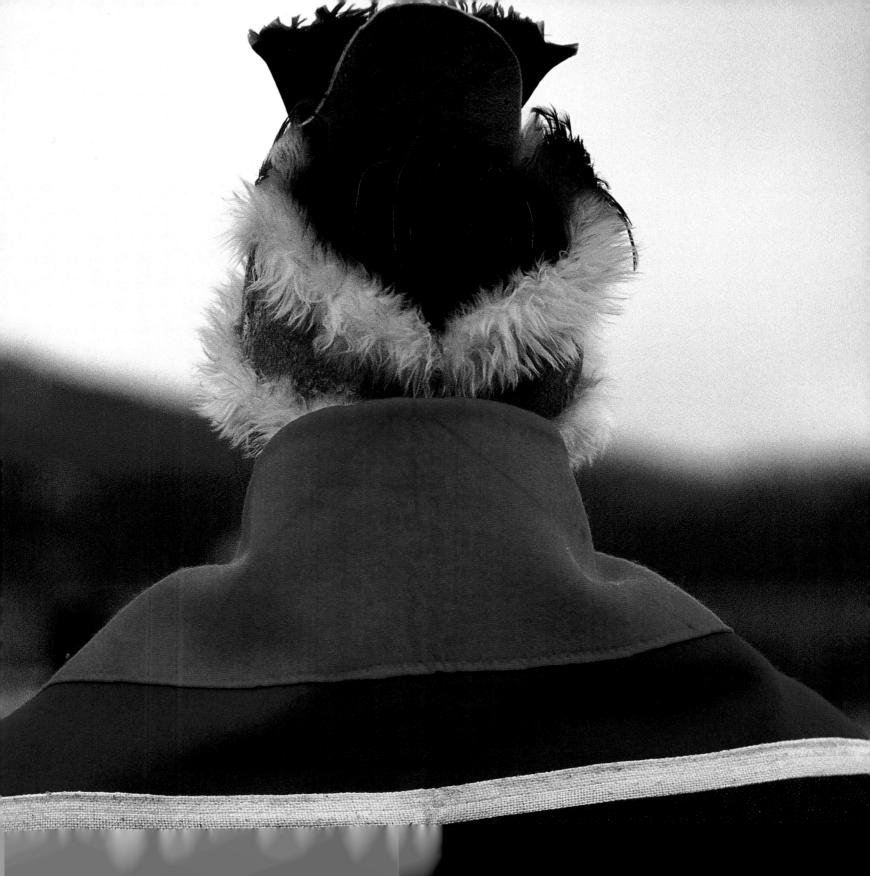

Until the Steamboat Came . . .

His head befuddled with the smoke of the peace pipes and Three Star Whiskey, Jack listened to the Indians' stories hour after hour. The potlatches, the wars, chiefs who triumph, others who fall, daring ambushes and heads chopped off to win a wife. . . . One evening among the tales of battles, betrayals, and victories, a chief spoke of a new war. Despite the heat of the arctic summer and the midnight sun, the men were gathered around a fire built to chase away the cloud of mosquitoes that was pestering them. The old man tells his story:

> *"And from that day I was both chief and shaman. And great honor was mine, and all men yielded me obedience."*
>
> *"Until the steamboat came," Mutsak prompted.*
>
> *"Ay," said Lone Chief. "Until the steamboat came."*
>
> —"The Sickness of Lone Chief," Jack London

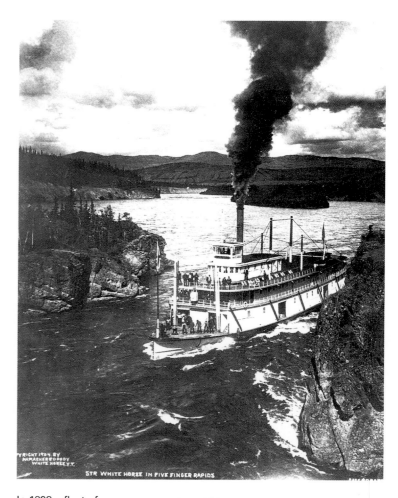

STR WHITE HORSE IN FIVE FINGER RAPIDS

. . . Until the steamboat came . . . bringing gold seekers by the thousands during the Klondike rush. In fact, it started long before, with the fur trade. In the eighteenth century the Russians turned up in en masse and spread terror throughout the Aleutian Islands and up and down the Pacific coast. Wherever they went, the sea otter was decimated and the local tribes reduced to slavery. But at least the Russians had remained on the coast and almost no one in the interior had ever heard of them.

In 1898 a fleet of steamboats is established to transport gold rushers eager to get down to work. The Yukon, until then frequented only by a few Indian canoes, is suddenly transformed into a major thoroughfare.

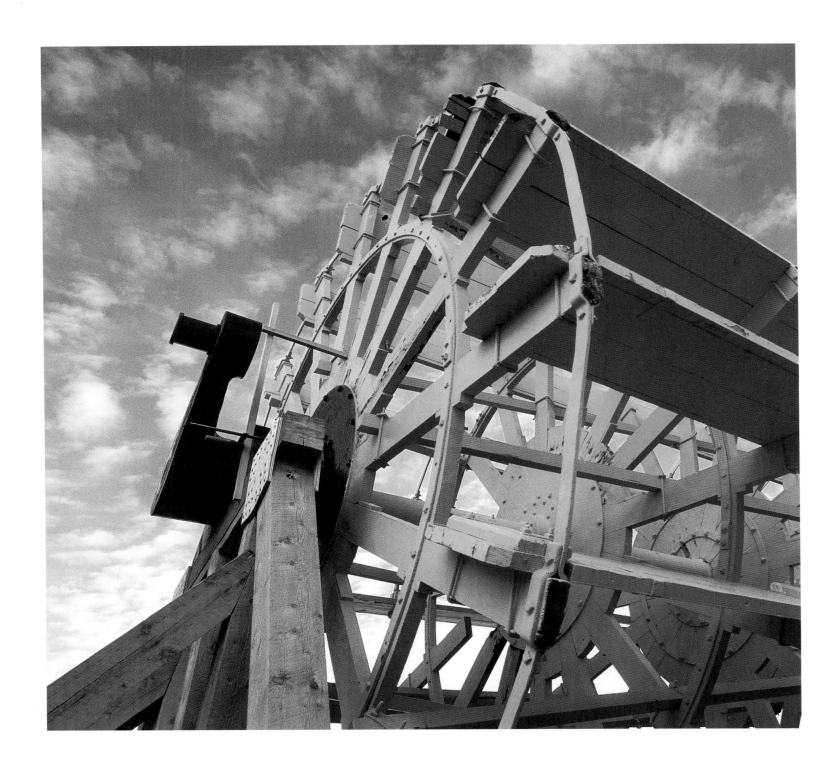

For more than a century, everything continued as it always had in Alaska's backcountry. Then one day the white men appeared. Trappers and prospectors, they came on foot, in canoes, and on dogsleds—and they were exhausted. The Indians welcomed them, nursed them, and fed them. But, once settled in, the white men rarely thanked those who had saved them. Sometimes when they left they took a woman or dogs with them in exchange for a rifle or some liquor.

Jack listened to the old chiefs' bitter tales and understood. He too had known oppression, in the cannery, among other hells, where he toiled fifteen hours a day for a pittance. Here in Alaska's backcountry Jack discovers another cruel facet of man's domination of man. He hears of women torn away from their tribes and forced to marry their white masters; Indian boys exploited in mines and driven to alcoholism; natives ravaged by the smallpox brought by the newcomers. Tribes are dispersed, families shattered. Since the arrival of rifles, the moose are growing scarce. The rivers have been poisoned by the mercury used by the prospectors to separate gold from rock. In a short time, the Great Land has been defiled—and it appears that the waves of white men will never end.

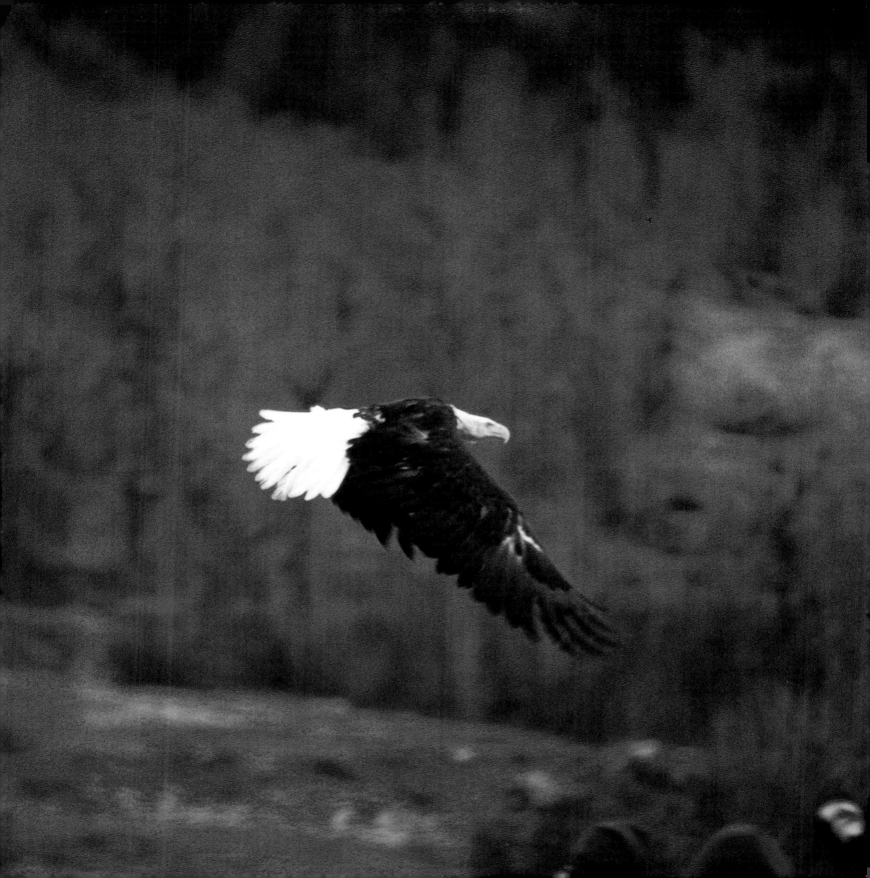

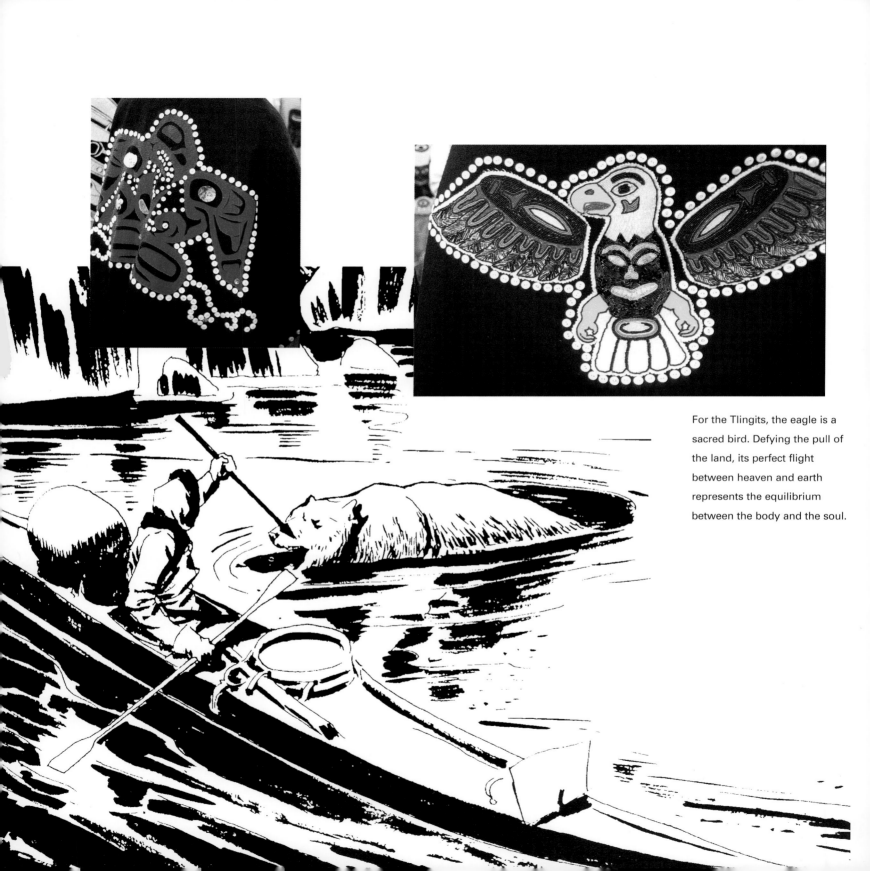

For the Tlingits, the eagle is a sacred bird. Defying the pull of the land, its perfect flight between heaven and earth represents the equilibrium between the body and the soul.

"The old people, back seventy years ago, right here, we had white men. Some of them would come up with nothing and we invite them. We live in tents, not in cabins so we stand out in the bush. And they live with us. They gotta eat meat, fish, beaver, bear, whatever we cook they eat. And they learn how to hunt. So they were nice to us. They gotta be. They got nowhere else to go. But white man would not help another white man! White man too selfish. So we had a lot of them here. And back in those days you could settle where you wanted. You don't have to homestead. That's yours. You move, cut wood, hunt rabbit, moose, that's your place. I don't bother you because I've got my own place over there. We don't go in your country and kill your mooses because you've got a big family to live too. We don't do that, we respect each other. White men don't do that.

They came over right here. Even today you don't see Indians working in the city. No, white man got it. All the jobs. Right today they got all the jobs because we were too dumb. They got white man teacher, white man nurse, white man storekeeper, bartender, white man cop, white man judge. No Indians. Back when I was a little kid, they used to put Indians in jail for getting drunk and shooting a moose. You get a moose, somebody turn you in, you got ninety days in jail for that. They don't give a damn if you have six kids at home to feed, they put you in jail. You got no money to pay your fine so you gotta stay in there. That's what I was caught on, I think about it. I did not go to jail for doing that but my dad did and he couldn't win the case. Why? Because the judge was a white man. White woman she was. If it was an Indian judge, it would be even. We're not gonna take from you because you're white, we have a right of our own too. We don't try to hurt your people. That's your people that wanta step all over us. That's god's truth. No, I don't give a damn about them. No way. They spoiled the country here."

—Al, eighty-six-year-old Native American,
Nenana, Alaska (October 2003)

Throughout his long journey across Alaska, Jack listened and made the stories he gathered along the river his own. On June 30, 1898, weak with fatigue, he reached the port of St. Michael, where the Yukon plunges into the Bering Sea. From there he boarded a steamer bound for San Francisco. He had one obsession: to become a writer, whatever the cost.

The return to California was also a return to reality. Now he must support his family. And the gold he brings back from the Klondike? It's worth $4.50. So he writes furiously and unrelentingly, sending editors manuscript after manuscript, but with no success.

At last, in January 1899 the *Overland Monthly* publishes one of his first short stories about the Klondike, "To the Man on Trail." Remuneration: $5.00. Others follow, and a year later one of the most prestigious East Coast magazines, *The Atlantic Monthly*, publishes "An Odyssey of the North." It is an instant success and the gifted young writer is baptized the "Kipling of the North." In April 1900 his first book appears, *The Son of the Wolf*, a collection of eight Klondike stories.

Then in 1902 he publishes *Children of the Frost*, a collection of stories devoted entirely to the northern Indians. He depicts the world as seen through their eyes and plainly portrays "the whole vast tragedy of the contact of the Indian and the white man."

The following year, *The Call of the Wild* is published. More than six million copies will be sold.

The former child of the slums would not make his fortune from Klondike gold after all but with its stories. He became the best-paid writer in the world in the early twentieth century.

Despite the triumph of *The Call of the Wild* and of the dozens of novels, short stories, and essays he publishes later, Jack London always considered "The League of the Old Men" his finest short story. It describes the fate of Imber, an old Indian who can no longer endure the "the white men [who] come as the breath of death." Imber organizes the old men of his tribe and launches a war to annihilate the white invaders. He kills one, then five, then ten, sowing fear in the region of Dawson. But when he realizes that more will always come to replace them, Imber loses all hope and surrenders. He goes to Dawson and confesses to his crimes in court before a horrified crowd. Ironically, it is Howkan, a young Indian brave who has gone over to the white man, who must interpret his words for the judge.

"I am Imber, of the Whitefish people. My father was Otsbaok, a strong man. There are no Whitefish now. Of the old men I am the last. The young men and young women are gone away, some to live with the Pellys, some with the Salmons, and more with the white men. I am very old and very tired, and it being vain fighting the law, as thou sayest, Howkan, I am come seeking the law."

"O Imber, thou art indeed a fool," said Howkan.

But Imber was dreaming. The square-browed judge likewise dreamed, and all his race rose up before him in a mighty phantasmagoria—his steel-shod, mail-clad race, and lawgiver and workmaker among the families of men. He saw it dawn red-flickering across the dark forests and sullen seas; he saw it blaze, bloody and red, to full and triumphant

noon; and down the shaded slope he saw the blood-red sands dropping into night. And through it all he observed the law, pitiless and potent, ever unswerving and ever ordaining, greater than the motes of men who fulfilled it or were crushed by it, even as it was greater than he, his heart speaking for softness.

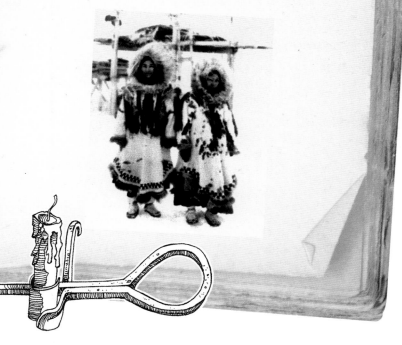

MINER'S CANDLESTICK MADE BY A KLONDIKE BLACKSMITH

Bibliography

WRITINGS BY JACK LONDON CITED

Smoke Bellew. Dover Publications: New York, 1992; first published 1912.

A Daughter of the Snows. J. B. Lippincott Company: Philadelphia, 1902.

The Collected Jack London. Steven J. Kasdin, ed. Dorset Press: New York, 1991; includes "The White Silence" (first published 1900); and "The League of the Old Men" (first published 1902).

The Call of the Wild. Atheneum Books: New York, 1999; first published 1903.

The Complete Short Stories of Jack London, eds. Earle Labor, Robert C. Leitz, III, and I. Milo Shepard. Stanford University Press: Palo Alto, Calif., 1993; includes "The Wife of a King" (first published 1899); "In a Far Country" (first published 1899); "The Law of Life" (first published 1900); "The Death of Ligoun" (first published 1902); and "The Sickness of Lone Chief" (first published 1902).

Other Writings by Jack London Consulted for this Book

"The Faith of Men" (1902); "Love of Life" (1903); "White Fang" (1905); "To Build a Fire" (1907); and "Morganson's Finish" (1906).

Acknowledgments

A very special thank you to Arielle Picaud and Michel Lelouarn, who designed the layout of this book. Thank you to Nicolas Vanier and Norman Winther for the use of some pictures and quotes taken during the shooting of the movie *The Last Trapper;* to Karl Gurke, Jean-Pierre Rigault, Jean-Pierre Burlot, Norman Winther and Al for the interviews they gave me and that I quoted in this book; and to Stephen Reynolds, manager of the Yukon Quest. A special thank you to Didier, Martine, and their dogs who are on the cover. A huge thank you to Christian Kunz, who welcomed me at his place for more than two months, and to Marc O'Bryan, whose help was priceless. Many thanks to artist Jim Robb.

And a great thank you to all my friends of the Yukon for their warm welcome and the unforgettable time I spent with them: Catherine Pinard, Peter Ledwidge, Eric Holle, Jean-Pierre Rigault, Claude and Elisabeth Dulac, Eric Oles, Alex Van Bibber, Gerard Cruchon, Andrée North, Frédéric Osson, Dodo Perri, Yann Herry, Pascal St Laurent, Didier Delahaye, and all the members of the AFY, Tammy, Dona, Trevor of the Beez Kneez Backpakers, Kate Weeks, and all the others. . . .

And of course thank you to Emilie Groues, Laurent Granier, Cyril Boissy, and Odile Bastille for their advice and help. A particular thank you to Jack London scholar Dr. Earle Labor, for reviewing the manuscript.

Illustration Credits

Reproduced by permission of: Jim Robb, Whitehorse: pages 4–5, 13, 27, 28, 33, 51, 53, 57, 58, 64, 65, 70, 74, 81, 111; Yukon Archives, Whitehorse: pages 15, 16; P87-0661 Alaska State Library Winter & Pond Photography Collection, pages 18, 22, 28, 34, 48, 52, 55, 57, 58, 65, 70, 75, 80, 92, 104, 108; Yukon Quest International: pages 33, 40; The Huntington Library, San Marino, California: page 3